Pastels
Unleashed

D0700768

Dedication

Dedicated to Malcolm for all his love
and endless support, and his belief that
I can do anything I put my mind to ... not
to mention his excellent photographic
contributions to this book!

Pastels
Unleashed

Margaret Evans

Search Press

Pastels Unleashed

First published in Great Britain 2014

Search Press Limited
Wellwood, North Farm Road,
Tunbridge Wells, Kent TN2 3DR

Reprinted 2014, 2016

Text copyright © Margaret Evans 2014

Photographs by Paul Bricknell at Search Press Studios
Photographs and design copyright
© Search Press Ltd 2014

All rights reserved. No part of this book, text, photographs or
illustrations may be reproduced or transmitted in any form
or by any means by print, photoprint, microfilm, microfiche,
photocopier, internet or in any way known or as yet unknown,
or stored in a retrieval system, without written permission
obtained beforehand from Search Press.

ISBN: 978-1-84448-908-4

The Publishers and author can accept no responsibility for
any consequences arising from the information, advice or
instructions given in this publication.

Readers are permitted to reproduce any of the items in this
book for their personal use, or for the purposes of selling for
charity, free of charge and without the prior permission of the
Publishers. Any use of the items for commercial purposes is not
permitted without the prior permission of the Publishers.

Suppliers
For details of suppliers, please visit the
Search Press website: www.searchpress.com.

Publisher's note
All the step-by-step photographs in this book feature the
author, Margaret Evans, demonstrating pastel painting.
No models have been used.

Printed in China

Acknowledgments

Thank you to Roz Dace for choosing me to
unleash pastels and work with Search Press
again, to Sophie for deciphering my rambling
text and turning it into something constructive,
and to Paul and Juan for their photographic
talents, making my simplest scribbles look
interesting. Thanks also to all my students,
near and far, who continually support me,
attend my workshops and stretch me to my
artistic limits, whether they attend weekly,
monthly, annually or occasionally. And finally,
thanks to IAPS (International Association
of Pastel Societies) for its dedication in
promoting pastels to the world and creating
an international, multi-lingual family of artists
who help to spread the gospel!

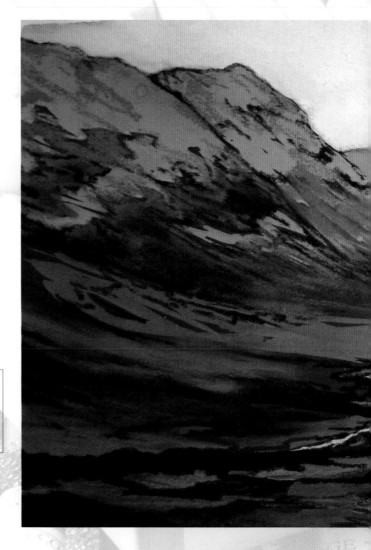

Contents

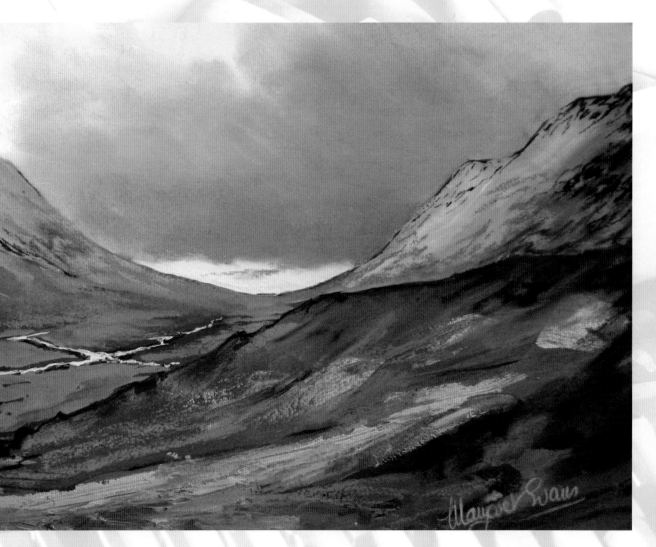

Introduction

I would like to help you unleash your pastels, tempt you with their versatility and show you how exciting they can be so that you can share my enthusiasm, even if I am biased! Pastel is pure pigment and the most direct and spontaneous medium you can paint with, thus suiting many different painting styles. Some have the preconception that pastels are just coloured chalks; rather messy to work with, totally unstable, and only worthy of loose sketches. I aim to explode this myth, help establish pastel as a serious painting medium, uncover its forgiving qualities and capabilities and unleash its many faces and forms and its suitability for both beginners and experienced artists. Above all, I want you to have fun with pastels!

Though artists have used pastel since Leonardo Da Vinci's time, Edgar Degas (1834–1917) brought real credibility to the medium, making colours strong and luminescent, combining them with other media, and experimenting with various paper, cardboard and canvas surfaces to paint on. He mixed pastels with gouache and watercolour, and steamed them to soften the pigments. With brushes, he blended colours and media, dipping pastels into prepared solutions and fixing each of the layers, thus popularising and advancing the knowledge of fixatives. Thanks to him, pastel was no longer considered a pale, insipid medium. Many artists have followed on from Degas over the years, and my inspirations have ranged from James McNeill Whistler's (1834–1917) sketchy renditions of Venice and Henri de Toulouse-Lautrec's (1864–1901) stunning figures, to Mary Cassatt's (1844–1917) sensitive pastel portraits. Nowadays pastels stand alongside oils and acrylics, and Pastel Societies worldwide help to spread the gospel and dispel the myths, so the medium is truly 'unleashed' in any number of ways!

I didn't discover pastels until after I graduated from Glasgow School of Art, and until that point, I painted only in oils. When someone suggested I try pastels for portraiture, I discovered the similarities in the way the two media work. Oil paint is relatively sympathetic to the artist's wishes, stays where you place it (unlike watercolours) but moves if you want it to, especially after a period of time (unlike acrylics). Pastel has similar mobility. It can be placed thickly or thinly, and can be moved by blending, spreading and dissolving. Colours can be mixed directly on top of each other, glazed to show underpainting and used to create mood and atmosphere. It is an ideal medium for *plein-air* painting, being immediate and spontaneous. Pastels can be used wet or dry, they blend with water, and are painterly, atmospheric, subtle, vibrant or sketchy. All that from one medium!

Whether you work indoors or outdoors, pastels will only be bulky if you allow them to be. Although your entire collection of pastel sticks can be laid out in a studio situation, with colours, tints and shades displayed, outdoor work requires a simpler approach, cutting back to basic palette choices and mixing colours on site, rather than expecting to find the exact tone or tint you are looking for in the box.

I have taught and painted in all media for over thirty years. I enjoy oils for their texture and consistency, acrylics for their convenience and immediacy, gouache for its opacity and texture, and watercolour for its fluidity and luminosity. But as pastels can show all of these qualities in wet or dry form, they have to be my favourite! I have been fortunate enough to travel round the world, meeting artists and Pastel Societies internationally, and widening my own knowledge and appreciation of this medium. I am a proud member of the Pastel Society of America, Pastel Artists of Canada, and Art du Pastel in France. The International Association of Pastel Societies (IAPS) does a wonderful job, connecting pastel artists worldwide, and through its work, exhibitions and biennial conferences, keeps artists connected with the manufacturers, who work hard on developing and improving our pastels. Let's hope we all continue to prove what an exciting and enjoyable medium this is!

Autumn Puddles

The photograph for this painting was given to me by a student, and I was attracted to its composition, taking the viewer's eye along the track, through the puddles, around the bend, to where? It unleashed my imagination and the colours just seemed to pop out, with a little exaggeration and artistic license.

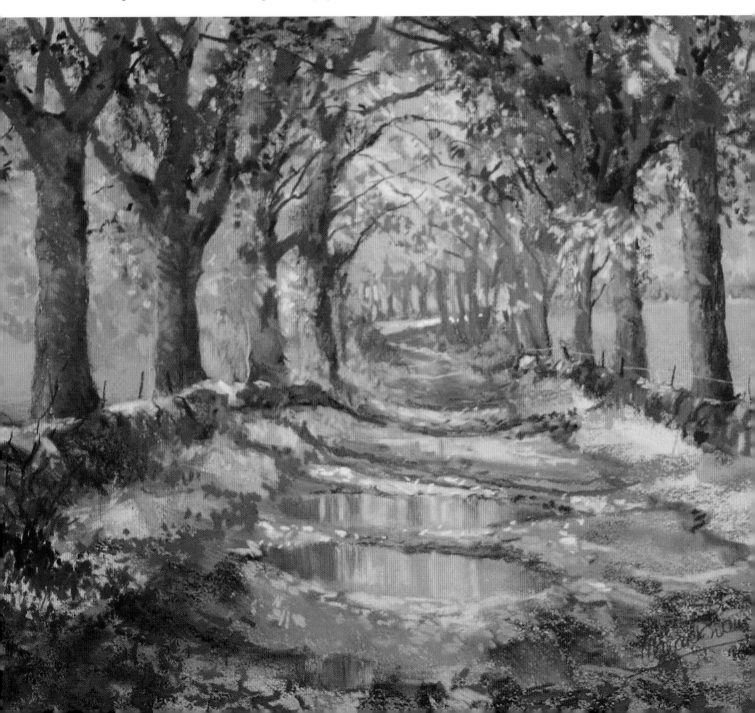

Materials
Pastels

There are so many different types of soft pastel that it is easy to become confused as a beginner. The simplest approach is to buy a basic set of soft half sticks and a cheap brand of harder sticks. Just getting the feel of dry pastel on your fingers will immediately tell you if you like this direct approach. You can use surgical gloves and/or masks if you feel you may have a reaction to the dust, or try pastel pencils for a more precise handling. However, to 'unleash' the pastels and let them express their true identity, you need as few restrictions as possible, so the softer and bigger the pastels, the looser and more creative you will be!

Pastels come in all forms, from soft to hard, round to square, even pans of lush colour to make the mouth water! The hardest types tend to work out cheapest, as they usually have less pure pigment and more binders such as clay and kaolin. As the brands become softer, with more pigment content, the prices creep up, but a healthy mixture of both hard and soft is the perfect way to start collecting sets. Start with as large a basic set as you can afford. The bigger the set, the more subtle tones and tints will be included. From there, it is a lifetime's task to add to these sets, and this is best accomplished by buying individually, and supplementing the basic colours with darker and lighter values. Eventually the container boxes can be discarded for one empty box with sections, and sticks can be arranged in colour separations, then, within each section, arranged from light to dark. This is the ideal work box – to save on space, pastel sticks can be broken in half or thirds, making them much easier to apply in different methods, and the spare pieces can be kept in the original manufacturer's boxes and become 'stock boxes' for replenishing, when a colour runs out in the work box. If you do not have studio space to set out your pastels permanently, this work box can be packed away, and put in the back of the car for taking outdoors. You can even keep a smaller version for packing into luggage for travelling overseas. There are easels with arms that support these boxes, making it easy and comfortable to work outdoors.

Photograph by Malcolm Evans.

Pan pastels are a wonderful supplement to your pastel stock, as they are pure pots of colour, applied with various shapes and sizes of sponge and spatula, and ideal for covering large areas such as skies. Pastel pencils are also a useful addition as they offer greater control for linear work, though there is no doubt they encourage you to 'fiddle' more than other types. But there is a place for each, and by starting with the basic suggestions above, artists individually learn what kind of additions they need, as their work develops.

With any outdoor painting kit, it is essential to take as little as possible, and make sure each item you carry is working for its keep. A good tip is to check your kit when you get home, and place each item in one of two piles: one for the items you used that day, and one for the things you didn't use at all. This helps reduce the kit radically, and makes it easier to transport.

Photograph by Malcolm Evans.

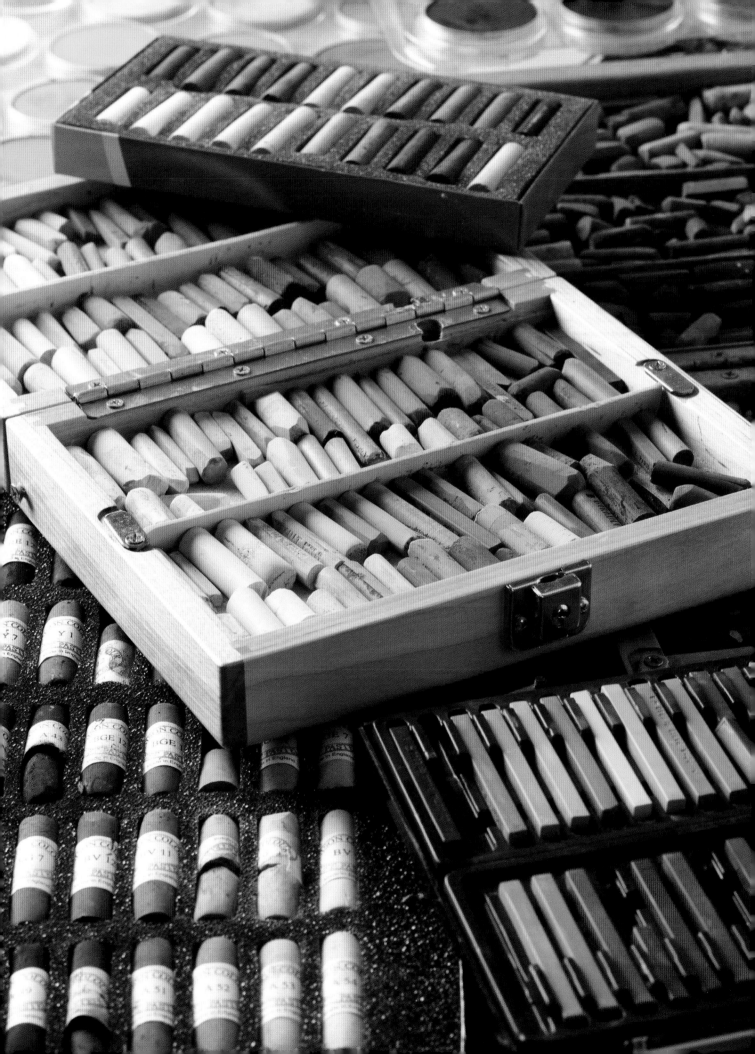

Paper and supports

Pastels need texture on their papers and supports to help the pastel to grip the surface. The supports you can use range from fibrous textured papers to sanded surfaces which are grittier. Pastel papers are available in a variety of colours and tints. These are good if you are starting in pastel as you can experiment with different textures to get used to the 'tooth' which grips the pastel, and try out different colours and tones if you have only worked on white papers before. It takes a while to get used to the paper's colour or texture showing through, and you quickly realise that applying pastel thickly or thinly will give very different results because of the underlying colours. Most papers come in large sheets which can be cut to size and taped on to a drawing board, and it is best to work on a cushion of several layers of paper to give a slightly softer base to work on. Pads of paper are good, and some have protective sheets in between which can be taped down when a painting is finished to prevent smudging.

I treat the work produced on these types of paper as sketches, as they don't take as many layers of pastel, compared to heavier weight boards and supports. However, sometimes a little masterpiece may appear, because it is lighter, freer and sketchier, and is therefore perfectly acceptable as a real painting! I only use these papers for dry techniques though, as any wetting will cause buckling and breaking down of the paper's texture.

My favourite of the stronger supports has a gritty texture applied to a strong watercolour paper, which is designed to take plenty of layers of the softest pastels. It can also can be wet to create more painterly techniques, and is available in an exciting range of colours. There is also a 'supertooth' version, which is even grittier if you prefer a rougher texture. The primers used on these papers can be purchased in tubs, for preparing your own surfaces, such as watercolour papers, gatorboard, hardboard or Masonite, and even canvas. Other surfaces I use are sandpapers specially formulated for the art market, which are available in varying textures from p200 right up to a smoother p800, and can be used for wet and dry techniques and take unlimited amounts of pastel. Although these heavier duty supports are more expensive, they can be reused over and over again, and even washed under a tap to take off excess pastel layers if you are starting a new painting on top of an old one. This can be a fun exercise, as well as being thrifty, and it creates more imaginative effects if some of the old paintings are left to show through. Remember, to be unleashed is to be free, take risks, experiment and have fun with your materials!

Preparing your own grounds

Some artists prefer making their own grounds and creating new surfaces to work on. Once you have tried a few commercially available surfaces, you will have a better idea of what surface you would prefer, and preparation can be a fun way to create something unique to work on. I love creating new surfaces and colours to work on as the ground colour is a huge inspiration to me, and pivotal in the development of my paintings.

The support you choose for preparing must be sturdy and acid-free if possible, otherwise sizing is necessary to create a barrier. This is why watercolour papers are ideal as they have already been prepared, and offer such a wide variety of textured surfaces even before you add a gritty texture to grip the pastel.

The ground is the surface the pastels adhere to; therefore it must contain grit to create the 'tooth', together with a thinning medium such as acrylic gesso or acrylic gel medium. This mix can be painted on to various surfaces, so experiment with different boards to find your preference. Some prefer a stiffer board such as hardboard, whereas others prefer a slightly softer 'give' such as mountboard, canvas or watercolour paper, which must be a heavy enough weight such as 640gsm (300lb). My choice is to mix pumice powder with acrylic gesso and an acrylic colour. Below I show how to create a random background wash ready for painting, on a gritty sandpaper.

Underpainting a random wash

I love creating new coloured grounds to work on, sometimes as complementary colours to the theme of the painting, or simply random colours that excite and inspire me. By painting my subject on top, I get radical, contrasting colours coming through, which help the creativity of the colour scheme.

1 Use a very gritty sandpaper. Take any colours you like and paint them on to the paper. I have used purple, turquoise and orange.

2 Take a large flat brush and wet it with water. Dab into the background colours, moving the brush in different directions. Keep re-wetting the brush and applying more water to the painting so that it drips.

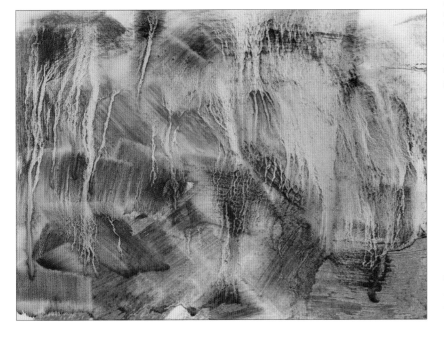

The ground prepared with a random wash. Lots of textures emerge with this technique, especially on sandpaper.

Underpainting a related wash

Sometimes I use colours related to the subject I am about to paint, simply to create the colours and atmosphere I am going to use. For a Tuscan landscape I will place a pale turquoise at the top, pink next, then turquoise, then light green, to suggest the bands of colours in the landscape.

1 Suggest the sky with turquoise at the top, and bottom, then pale pink in the middle. Graduate the turquoise at the bottom of the sky into a light green.

2 Use a large flat brush with lots of water to brush into the background.

3 Clean the brush with each new colour so that you do not muddy the colours. Continue adding water, allowing drips to form and creating texture.

4 Change the angle of the brush to suggest landscape features.

The ground prepared with a related wash.

Preparing watercolour paper with a random wash

It is good to experiment with different paper surfaces, and Rough watercolour papers can offer an alternative texture, especially if you plan to throw a lot of water over your pastels and test their solubility. As watercolour papers are designed to be wet, they will respond well to wetting, and be more absorbent.

1 Apply your background colours. I have used yellow, red and purple. The purple is a harder pastel.

2 Wet the large flat brush and brush on water, moving about the colours and blending some edges. Wash the brush before wetting each new colour to avoid muddying the background.

3 The harder purple pastel creates more of a resist, so a different texture emerges when you brush water into it.

4 Change the angle of the brush to suggest landscape features.

The finished watercolour paper ground.

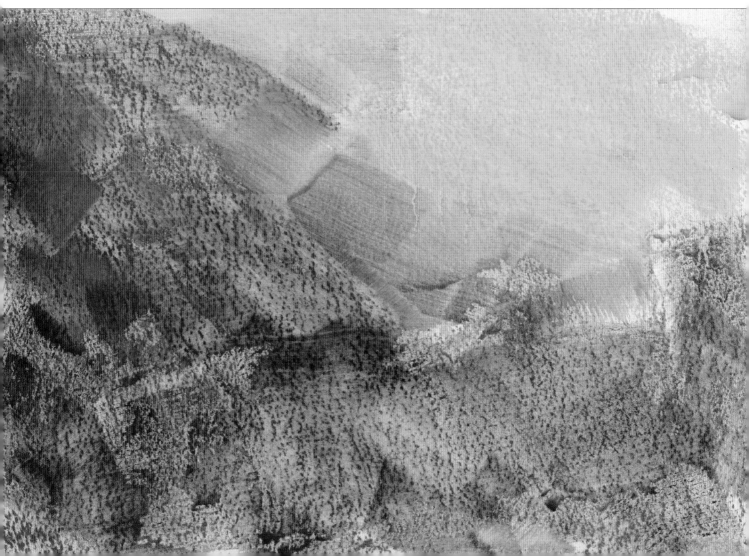

Brushes and sponges

Brushes are particularly important for wetting the pastels. Hard bristles will remove too much pigment from the surface, therefore softer brands are better, though avoid using anything with sable which will quickly wear away. The best types are synthetic acrylic brushes which feel soft but are strong and durable. I find flat brushes the best as they make 'painterly' marks which cover the ground better, and I encourage large blocking in to get down the design of the composition at an early stage, which shows the dynamics of the painting. Flat brushes are also better when wetting later layers of pastel on top of previous layers, as they do not disturb the underpainting as much as pointed brushes, which would also create fussier marks. In pastel, developing as many varied marks as possible is important to create volume and texture, rather than relying on the texture of the support, which can be too regular.

Colour shapers are made of rubber and make creative marks according to the shape used. They are available in flat, pointed or angled shapes, and help to smooth out areas, apply details and scumble edges. Sponge shapers are also useful, in round, square, triangular and oval shapes, to vary mark making, and for use with pan pastels. Paper torchons are useful for rubbing areas where a smooth finish is required, and for picking up pastel dust to draw with for creating details.

Other materials

Other useful sundries are kitchen paper for rubbing off excess pastel, and a mahl stick for working into areas and avoid leaning on the painting. A ready-cut mount is handy to view your work near completion and review which areas need attention. An old bristle brush is useful for removing pastel when the paper surface becomes overloaded and the 'tooth' needs to be accessed to apply further layers. Other props include a sturdy easel which holds the board upright, allowing the excess pastel dust to fall downwards rather than lie on top of the painting. Some easels have a flat tray attachment at the front which is ideal for laying your pastel box on; more expensive easels have the box incorporated, like field easels. There is no doubt that you could spend a fortune on all the right kit – however you have to assess your commitment to any medium first before investing heavily.

Gouache is useful for underpainting and blocking out the paper colour in areas where it does not need to show through, as well as for placing highlights against a dark-toned paper, to show how the tonal balances work together. A small plastic palette is suitable for mixing this, and a small polystyrene tray is useful to select the pastels you are going to use in the painting

Pastels can be wet with turpentine, and/or spray fixative, which is also useful for spraying when completing stages, but for outdoor work, I simply take water for wet techniques.

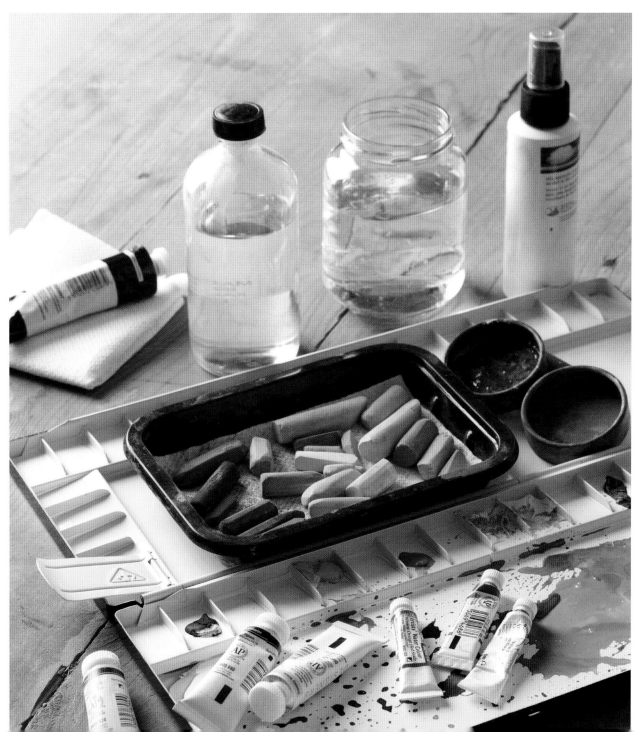

Indoor set-up

A separate space is always best if you plan to paint indoors, if possible where pastels can be left out undisturbed. If you are lucky enough to have a studio room to set aside for pastels, it is easiest to lay them on work surfaces in colour sections, keeping all the yellows together, blues together and so on, rather than in their original manufacturers' boxed sets. I have hard and soft brands sitting next to each other which are identifiable by shape as you get to know them better. I keep greys separate, as they tend to dirty other colours, and each colour section is divided into pale tones, mid strengths and darks. Other sets I keep separate are thin, hard pastels, as they are ideal for detail and for correcting any drawing issues that crop up as the painting develops. I also have a set of pastels which match exactly the same manufacturer's range of paper colours. A set of soft whites is set aside too, as different tints of white and the palest of pale tints are useful for adding final touches without resorting to pure white, which can appear chalky in comparison.

Brushes, mahl sticks and sponges are at close range for wet and dry techniques. Paper towels, plastic palettes for gouache or watercolour underpainting are nearby, and small polystyrene trays are also stored in the studio as they are useful for selecting colours to work with for each painting, to separate them from the masses. This also helps to identify weaknesses in a palette selection, similarities in tonal values, or inadequate colour options. Papers are either packed flat in large plan chest drawers or stacked in pads, and completed pastel works are stored flat on shelves with protective papers between them to prevent smudging.

Lighting is important not only for painting, but also for identifying the colours you are looking for. Roof lights allow plenty of natural daylight in, but not direct sunlight, which is to be avoided as it can fade colours. If you don't have a roof light and natural light from windows is limited, then daylight bulbs or tubes are excellent.

Once you have gathered all of the above into a dedicated studio space, it becomes your sanctuary, where no one should touch or move anything, keeping it sacred.

For subject matter, I work either from photographs, which I stack in boxes, or from painting diaries which I take on my travels. Many great subjects that I don't have time to paint in situ have become quick sketches in my diaries, with appropriate photographs taped in beside them, so I have all the information in one place when I decide to use an idea to paint from. When I am working on an idea that is an amalgam of thoughts, photographs and sketches, I create a montage – a type of storyboard where all the reference is gathered together; for instance I may take several sections from different photographs to put together and use a colour scheme from something else to combine into a more imaginative, creative painting. Workbooks full of these montages are also stored in the studio.

Photograph by Malcolm Evans.

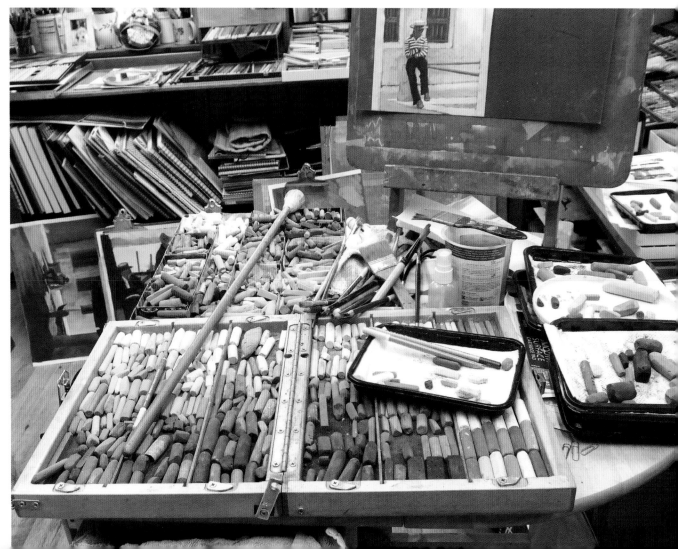

Outdoor set-up

My travel work box makes outdoor pastel painting easy to manage. It is handmade and beautifully designed. It opens like a briefcase with sections on both sides, held in place by lids that swivel. The box must be laid open in a flat position before taking the lids off. Each side has three sections for colour sorting, with pastels arranged in reds/oranges, yellows, ochres/browns, blues/purples, greens and neutrals. Each colour section is also organised from light to dark tonal values. When selecting which pastels go into this travel box, I break long sticks to approximately a third of their length, around 2.5cm (1in) long. This allows me a wider range of colours in the box, and the extra pieces are left indoors, either in my workspace, or in stock boxes for replenishing the pastels laid out in my studio. These can have the wrappers left on to identify later, when replenishing.

The travel box has a screw attachment underneath which fits on to a camera tripod, and there is also an easel-top attachment which fits into the box for holding my board and papers. Sometimes I don't take these attachments, and just use a separate easel, propping the box on a rock or a stool outdoors. If I choose to sit and paint, my stool is low enough that I can place the box on the ground and reach it as I work. Either of these set-ups is ideal for comfort, and also for a quick exit if the weather suddenly takes a turn for the worse!

I prefer to work with loose papers, and usually cut my sandpapers and boards into half or quarter sheets, around A2 or A3 size, and tape them inside a folder made from lightweight foam core board, cut in two and taped with duct tape. The spare sheets and finished paintings are stored in the folder, and it also serves as a drawing board to lean on. The board fits into my suitcase when travelling abroad, therefore all my paintings travel home flat and safely, each one usually covered with newsprint or old newspapers for protection. This is an ideal way to store them flat on shelves when I get home, until I am ready to work on them or use them as reference sketches.

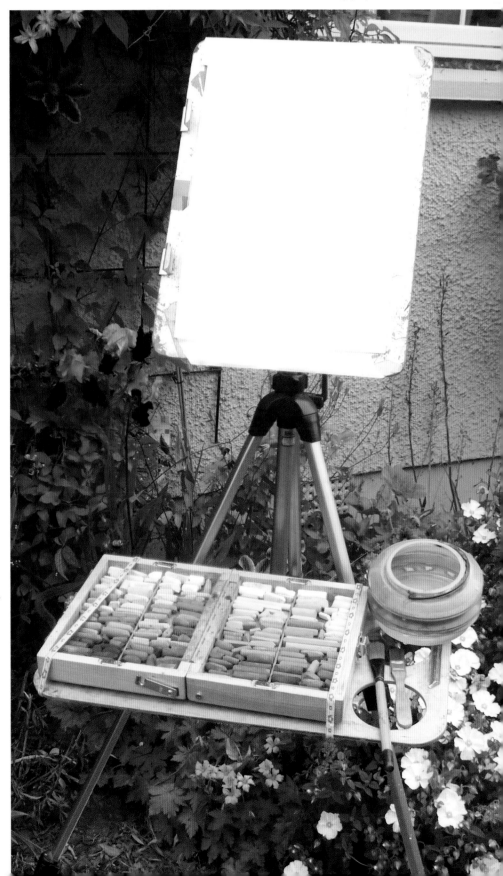

Photograph by Malcolm Evans.

Colour

There are thousands of different pastel colours, mixes and tints, which can make choosing difficult. Colour is also a personal issue: some artists will restrict their palette to the bare minimum of just primary and secondary colours, and mix everything else. Some prefer to have every riotous colour imaginable and paint with lots of colours within one painting. To learn colour basics, you have to strip back to the bare essentials and understand how colours work and mix with each other. Then you can let imagination and constraints go, and buy as many extra colours as you like! Starter boxes are best to begin with, then learn to control and mix, and later add additional dark and light tints and expand the colour range. Keep the manufacturers' brochures and colour charts, as they are full of good advice and information and allow you to keep a check list of the colours you have bought, and plan the next ones you need. Remember, this is a love affair...you will want them all, and you'll never stop wanting more!

Everything we look at, and want to paint, will be affected by light, which will affect the colours we use. Before we start to isolate objects to determine their individual colour, we should look at the overall picture we are about to create, and determine what colours are predominant. This will help us assess the limited palette we are going to use.

My basic palette of seven colours: lemon yellow, raw sienna, burnt umber, light red, permanent rose, French ultramarine and Prussian blue.

Basic colours

I have seven basic colours in my painting palette for watercolour, oil and acrylics: lemon yellow, raw sienna, burnt umber, light red, permanent rose, French ultramarine and Prussian blue. This offers two each of yellow, red and blue, the primaries. Each of these pairings offers a 'basic ingredient' primary which cannot be mixed, and what I refer to as 'nature's version'. For example, lemon yellow is a pure primary, but raw sienna is nature's yellow. Permanent rose is a basic red, but light red is an earth red. The two blues both offer natural basics, but one is more red-based and the other is green-based. By mixing two colours together, we can create interesting, clean and pure colour mixes. Burnt umber, the brown, is added to make dark tones, for example, mixed with ultramarine, it will make a more interesting black than a pure black, which is dead and makes other colours dirty when used in a mix. When mixed with Prussian blue, it makes an immediate and luscious dark green.

These seven colours need not be exact in their name – for example if I don't have Prussian blue, then a spectrum blue, phthalo blue or similar green blue will do. Yellow ochre can substitute raw sienna, and Indian or Venetian red is just as effective as light red. This is where personal choice comes in, and makes the palette your own. Add white and now you can start diluting the strength of the mixes and make wonderful pale tints.

Undoubtedly wet paint is easier to mix than dry, and with the basic colours mentioned you can mix virtually anything. Pastels, on the other hand, are pre-mixed colours, hence the vast range of colours available. However, there are still mixing possibilities. As with any other medium, too many colours mixed together will make mud. Colour mixing exercises can be achieved by laying

one colour on top of the other, but are also particularly exciting when water is added to dissolve the pastels. When dry, further colours can be laid on top to either strengthen or soften the mix.

It is possible to work within these limits of seven colours in pastel, if only to learn about overlaying and colour mixing, but you will quickly want to extend this to offer more variety for quickness and spontaneity. Pastels are so quick and tactile to work with, so it is fun to indulge in bigger sets of colours, so that you can lay on colour directly, without the need for mixing.

This study was done using just the seven basic colours from my colour palette, shown opposite.

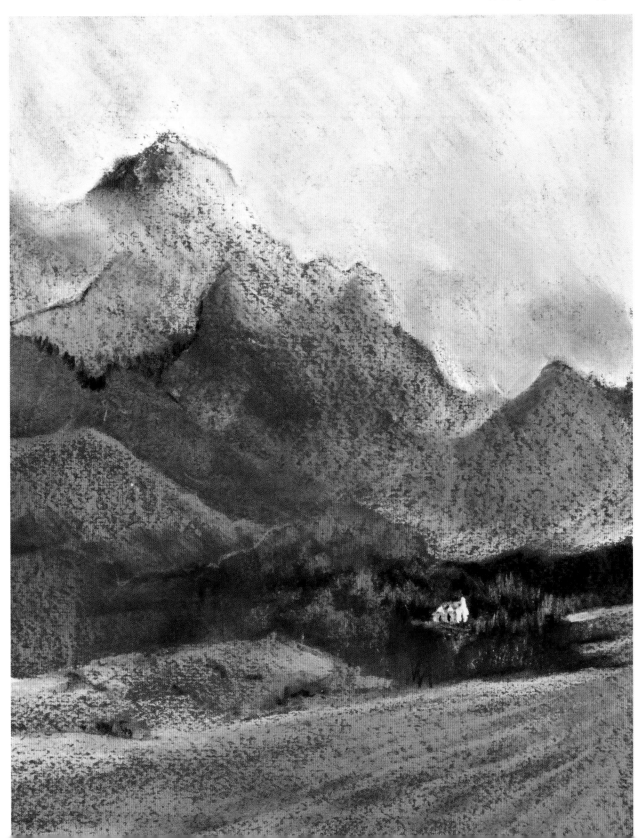

Mixing and adding colours

By familiarising yourself with the basic colours available, you will be able to understand some simple colour mixes. In pastel, it is best to avoid relying on manfacturers' names as there is a wide variety of brands with their own quirky descriptions, for instance, 'desert sand' could refer to New Mexico or the Sahara, sky blue also depends on which country you are in, and Burnt Reynolds or Moonshine tell you very little to aid recognition! Learning to be descriptive is much more useful, and helps you to find the more subtle colours, such as shades of grey, or skin tones.

I always omit black and neutral greys when teaching basic colour mixing, to help students understand simple mixing techniques. The more choice there is on a palette, the more likely you are to make mud, so by stripping back the choices, and learning the basics, we understand the theory better. For making greys, I always refer to the wet paint method when mixing watercolours, oils or acrylics; with pastels, take the same ingredients and overlay the colours until you get the desired effect.

Mix 1

In Mix 1, I have used ultramarine with burnt umber, and overlaid one on top of the other. The lower half of the mix has been blended with my finger to show how the fusion of colours works – it makes an interesting grey-black, which is much livelier than a dead black.

Mix 2

Mix 2 shows one of my favourite colour mixes for painting shadows: ultramarine with light red, which makes a dusky purplish-grey. Adding more red makes it similar to burnt heather, and with more blue, it is ideal for cloud colours.

Mix 3

Making instant dark greens can be problematic, but with Prussian blue (which is a greener blue than ultramarine) and burnt umber, a rich dark woody green is achieved easily (see below). Add a few different yellows to this and you will cover a range of natural greens that are easy to remember, therefore easy to remix when you are trying to colour match.

Mix 4

Mix 4 shows that that our basic lemon yellow mixed with permanent rose (or a similar red) will not only give us orange, but by adding white on top, create a number of different shades of cream, from peach to a pale Naples yellow.

Learning to be descriptive helps enormously when mixing colours. If you make a two-colour mix and it isn't quite what you want, think about how you would describe it. Is it too warm or too cool? Does it need to be lighter or darker, stronger or weaker? The simple colour wheel of three primary colours (red, yellow and blue) will help you work out which way the mix needs to go – there is no need for complex colour wheels which baffle the beginner. Simply look and describe.

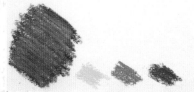

Mix 5

In mix 5, I have started with ultramarine blue and lemon yellow to make green.

I then mixed the same colours, but varied the amount, so there is more yellow in the first one, then more blue in the next. The third mix brings in Prussian blue to give a different green.

Here I have made a three-colour mix with Prussian blue, yellow ochre and lemon yellow to create a different green again. All this from our basic palette!

Overlaying colours using dry techniques

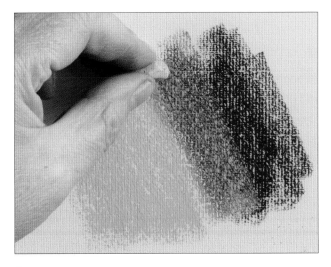 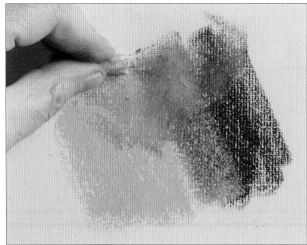

1 Block in an area of red, using the side of the pastel. Block in yellow pastel beside the red, then overlap the two, creating an orange mix in the middle.

2 You can then glaze a layer of white pastel over the top of the red, yellow and orange, to create a different effect.

Overlaying colours using wet techniques

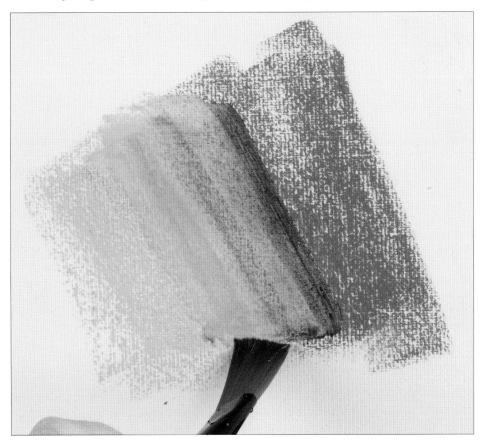

Block in an area of blue pastel, then an area of yellow beside it. Take a large flat synthetic brush made for acrylic painting. Wet the brush and use it to brush one colour into the next as shown.

Tonal values

After mixing colours, and making our own, we begin to realise that some colours are darker or lighter than others. When assessing the subject we are about to paint, we see that it has not only a colour theme, but a tonal range too, as the light source will also create shadows. Many of my students say they can identify colour, but find tonal values more difficult to interpret. The best way to learn is to limit yourself to one colour, such as brown or black (this is the one time I will allow you to use black!) and do a monochrome study. A greyscale chart is useful, and by making it yourself, you will learn how the pressure of the application of pastel can vary the tone. For example, on white paper, applying black very lightly will give you a light grey, and as you apply further pressure, the tone will become darker until the full value blocked in heavily will cover the white and produce pure black. All the lovely shades of grey in between are tones!

Sometimes, breaking the rule of no black can be useful when you want a particularly dark colour which is not available to you. Blocking out the paper colour with black like an undercoat, then adding the colour on top, will give you a deep, rich version of the colour; for instance ultramarine blue on top of a black base will give you a rich, dark blue like indigo. However, we can also expand our range of colours and tones so we can find what we are looking for in the box.

Another way of making darks is to apply a dark pastel thickly, then spray fixative from very close to the surface, to saturate the colour. It will go darker immediately and will also become solid colour. Extra layers of colour can be laid on top. Of course an alternative is to use black paper as the base, and allow it to show through in the darkest areas.

When organising your pastels in tonal grades in your box, you will immediately be able to identify what to add to a red to make maroon, or a blue to make indigo, as well as other colours which add light, instead of relying on white to lighten. Overuse of white can make colours dull and washed out, so these exercises are crucial to understanding colour and tone. They are also fun and enlightening!

In the swatches shown on the right, you will see in each of the columns a brown, black and red pencil, each applied in stages with different levels of pressure. Applying more pressure or adding several layers makes the tone of each colour darker. The top is the palest tint, the same tone as the paper, but the other five stages of each show how subtle or intense each colour can be according to the way it is applied. This seems too obvious, but I never cease to be amazed by the number of times my students tell me they don't have the correct tone or tint of colour in their box, when all they have to do is vary the pressure when applying the colour. So, the 'heavy-handed' artist, who tends to apply colour thickly, has to learn to hold back and lighten the amount of pressure, whereas the timid, 'light-handed' artist has to create more volume by applying the pastel more heavily. I call this 'fingertip control'. Every colour in your box has a job to do, not just to look like it does in the box, but to offer the palest tints and darkest darks; so work them well, and make each colour stick you buy work hard for its keep!

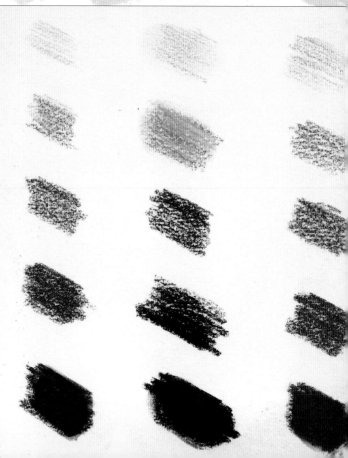

Brown, black and red pencil, applied with varying pressures to achieve different tones.

These two ten-minute studies of a castle show how the tones that you apply at the start of a painting are pivotal to how the painting develops and holds your own interest. I always tell my students to paint at this stage, 'as though the bus is leaving in ten minutes and will go without you if you're not ready'! In other words, get the important tones down as soon as possible.

Both these studies are on grey paper. In the first, the tones are too similar, although they do represent the actual colour I saw when looking at the subject. This shows the results you can get from being literal rather than imaginative. The artist works on a two-dimensional sheet of paper, and has to make the image come alive and look three-dimensional; therefore you need to overstate tonal values to push home the point.

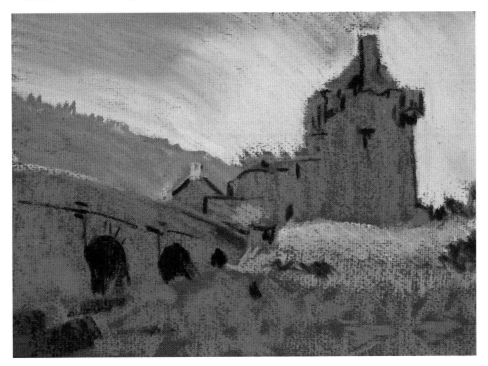

The first ten-minute study. The tones are too similar to make a strong painting.

In the second study, the same colours are used, but I have added a wider range of tones, and used counterchange to emphasise the point. Counterchange plays lights against darks and darks against lights. The colours you pick up to paint a subject may indeed match that subject, but it is what you put each colour next to that determines whether it is the correct tone.

In this case, I was also comparing each colour I picked up with the dark grey paper, which kills some of the colour strengths, whereas working on a white paper would show the true value of each tone. This proves that, for the pastel artist, it is important what paper colour we choose to work on as well as which pastels to use. Throughout this book you will see paintings where the paper colour influences and enhances the painting. For this reason, a matching pastel colour is always added to the limited selection to ensure that the original paper colour is still playing a part in the end result.

The second ten-minute study, which has a wider range of tones and uses counterchange, emphasising the contrast between darks and lights.

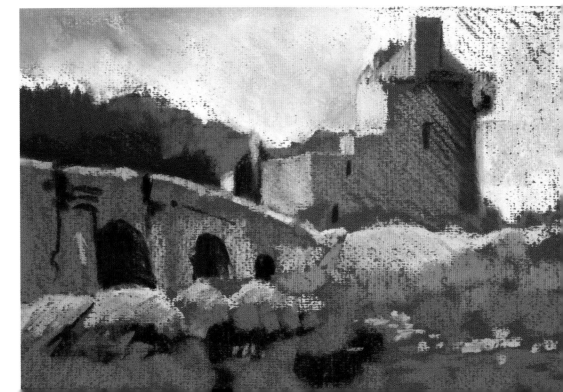

Techniques
Three basic stages

A pastel sketch or painting can be simplified into three simple stages, each with its own agenda for the development of the work. The sketching in simplifies the subject and places it on to the page to make sure it 'fits' well, and does not become complicated. The blocking in covers the paper colour either completely or lightly, depending on where the original colour is needed, and assesses the general colour scheme of the painting. The final stage, the build-up, completes the story to whatever level the artist wishes, whether it remain loose and impressionistic, or highly developed with more detail.

My palette of pastels used in this demonstration.

1 Sketching in

When starting off, it helps to assess quickly how the subject is going to fit on the page; therefore the large shapes have to be accommodated before the small shapes like details. My theory is that, if we can fit these large shapes in first, the smaller shapes will fall into place. Firstly I look for the outline or silhouette of the large shapes – even if you make no mark on the paper at first, just look at the subject and 'draw' an imaginary line round the outside, or perimeter, of your subject; you will immediately see whether the outline is a landscape, square or portrait format, which helps to assess the composition shape. Now, by drawing that shape on the page with the corner of a pastel stick, you can place the subject, without any details to confuse or complicate. Once this is done, the shape can be divided into 'sub-shapes'; for instance in landscape, distance, middle distance and foreground. Keep the lines loose and sketchy to allow you to make changes as you develop the painting. I usually use pastel, never charcoal, which would dull down the colours I place on top, or pencil, which would inevitably encourage too much detail too soon. Use a colour that will be included in the colour palette of the subject.

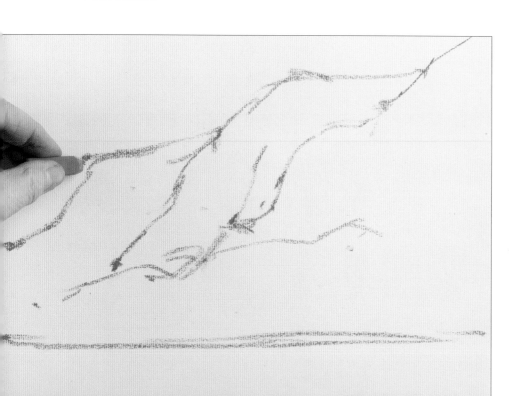

1 Take a colour that will be in the picture and sketch in the outlines roughly with this; I have used blue. Draw the larger shapes and general subdivisions, keeping it simple.

2 Blocking in

Now the basic shapes are in position, the colours and tones have to be blocked in, using the side of the stick to create a broad, painterly stroke. Break new pastel sticks to approximately a third of their length, creating a stroke similar to a flat brush when painting. This is a good time to consider the colours and tones you are going to use in the painting, so I prefer to select these in advance, either before I start the painting, or now, when the blocking in commences. The strokes should be applied lightly where the tone or colour of the paper is useful in showing through, and more heavily to cover the paper and hide its colour or tone in other areas. However the thick areas should not be so thick that they fill the tooth of the paper, otherwise in the next stage, you will be unable to add more layers. At this stage, it is possible to place colour on larger areas, then take a rag or sheet of kitchen roll to spread the colour, which helps to preserve the tooth of the paper.

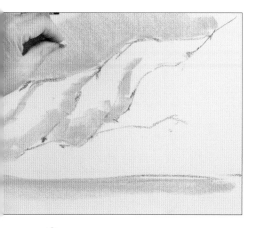

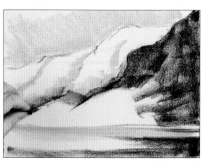

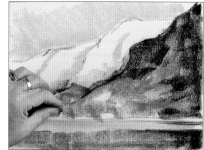

2 Using a lighter blue, block in the sky, then any areas that require the same pastel: here the shadows across the mountain and the surface of the loch.

3 Next block in the darker tones of the mountains and the lower part of the loch with a very dark indigo blue. You now have the light, mid-tones and dark tones blocked in.

4 The picture so far lacks warmth, so use an ochre pastel to block in the warmer parts of the land, then add their reflection with vertical strokes of the side of the pastel.

3 Building up

The building up process allows the artist to take the painting to whatever level of detail they want. By the end of the blocking in process, if all the colours, shapes, tones and forms are sitting correctly, the painting looks gloriously loose and dynamic. It is an ideal time to pause and consider your options before continuing. If you are working in the field, you can now stop and move on, especially if you are working in changeable weather conditions. Some areas might be perfect as they are, if they are loosely and freshly handled without detail, therefore I concentrate on the areas that are not reading right yet, or on the details that might be lacking around the focal point.

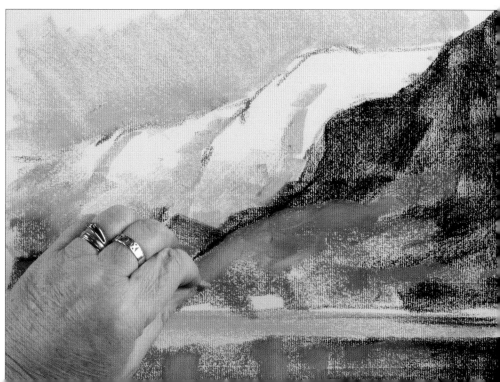

5 Use a light, warm fleshy pink over the lower part of the sky, then reflect this in the snow and go over the ochre part of the land.

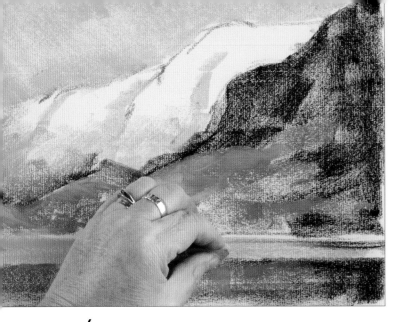

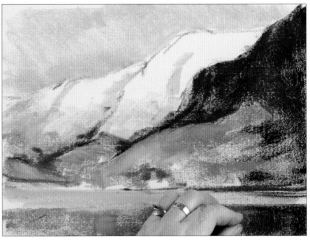

6 Apply turquoise over the sky area and the water, building up and varying the blues.

7 Use a dark brown to mark some of the divisions between the mountains, over parts of the indigo, along the shore and in the foreground.

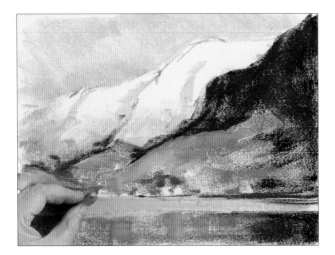

8 Make marks with the original blue pastel to suggest the shadowed side of the buildings. Use the point of the pastel for the smaller shapes.

9 Use a white pastel to reinstate white areas of the painting and create shape in the buildings along the side of the loch.

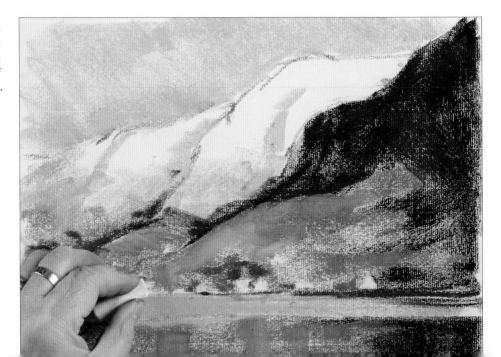

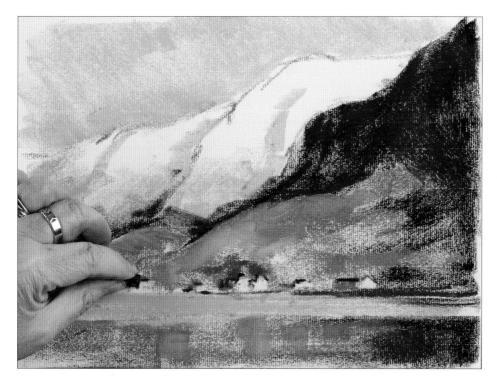

10 Use the tip of the dark indigo pastel again to add a few dots and dashes suggesting the darks of the buildings.

The finished sketch.

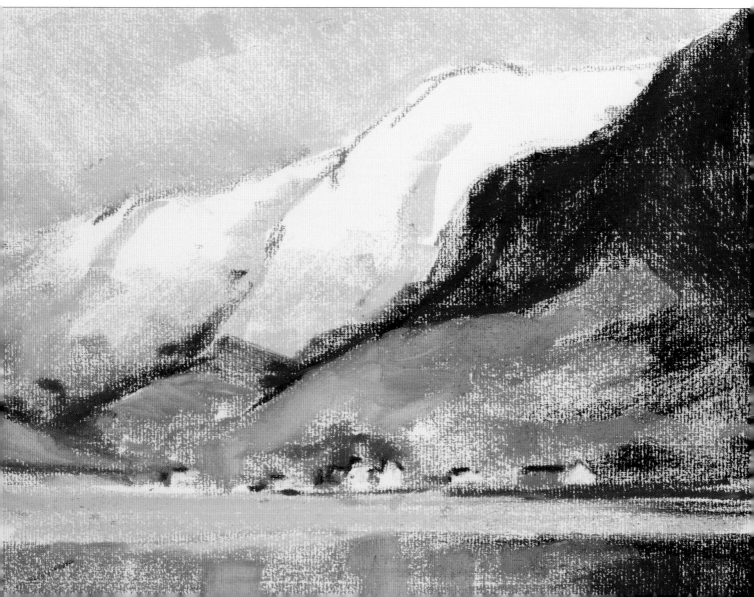

Dry techniques

Dry techniques are what most people think of when they think about pastel. They are really forgiving, as they stay where you put them, can cover over mistakes and be layered numerous times, and take as much overworking as any student will throw at them! Dry pastel paintings can be anything from quick sketches applied lightly on tinted papers, to solid built-up layers of colour, on rougher papers and supports with gritty texture, called 'tooth'. To familiarise yourself with dry pastel, I suggest using a selection of textured papers suitable for pastels in a mid-value colour such as grey or beige. This introduction to working on a coloured ground is useful if you have only painted on white before and helps illustrate how the paper colour plays a part in the development of the painting. If you are sure and confident, and can guarantee what you want first time round without overworking, then a lightweight paper will do; but for experimenting, building up layers, and covering mistakes time and time again, you will need the heavier duty types.

 Dry techniques rely entirely on the softness and grittiness of the pastel brands, as you will not be adding any fluid, such as water, spirit or turpentine. Different brands offer various consistencies: some are soft and creamy, some are crumbly, others hard and gritty. When starting with pastels, it is useful to stick to the dry techniques to help you get to know the different brands and their idiosyncrasies.

Glazing

Glazing is often thought of as a wet technique, as in oil painting, where one colour is painted over another transparently to mix colours. However, the technique can also be used in dry pastel to adjust a colour's temperature, add dark or light tones, or simply to mix colours and give a transparent effect. Several layers can be added on top of each other in this way, and thus, you are mixing colours directly on to the painting, rather than on a palette like other media. This fast and direct technique is easy to achieve outdoors, so is perfect for *plein-air* painting.

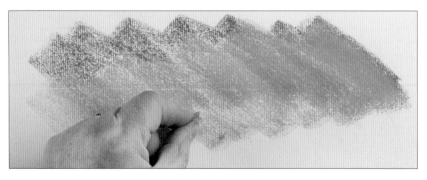

1 Apply blue for the top of the sky, using the side of the pastel and short diagonal strokes.

2 Glaze a lighter blue on top of this, moving the pastel in the same direction. The two colours will appear slightly blended as you apply the second.

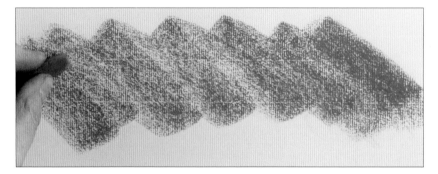

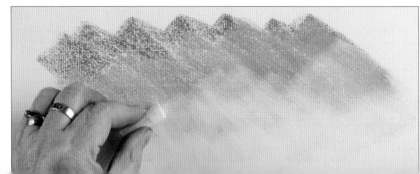

3 It is good to use a pastel that is the same colour as your paper background, in this case, white. Paint white at the bottom of the sky, overlapping the blues.

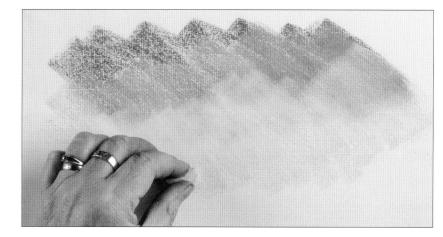

4 Paint diagonal strokes of light pink at the bottom of the sky.

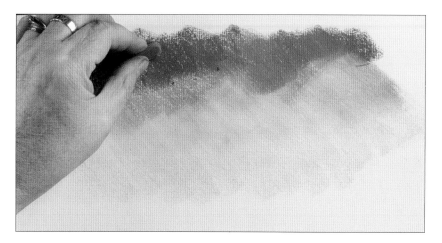

5 Strengthen the blue at the top of the sky by applying more of the first pastel you used.

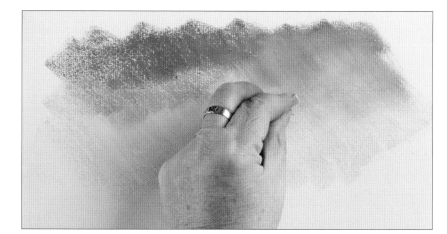

6 Now use a very pale blue hard Conté pastel over the whole sky. This blends the soft pastel colours underneath, and not much of the hard pastel comes off so it does not alter the colour very much.

The finished sky.

Layering

Layering is the process of placing layers of pastel over each other, and this basic build-up technique creates gradual variations, altering the colour or tone achieved during the blocking in process. Layering can be applied either by dragging the side of a pastel stick over an under-colour, or by broken strokes of colour which sit next to each other, creating a mix to the eye. When working on coloured grounds, once I have assessed where I want to use the colour of the base layer of pastel, I will lightly glaze on top in places, allowing the original colour to show through. In other areas, where I want to lay in a solid colour, covering the original colour, I apply the pastel more thickly. The underpainting can sometimes be applied with other media such as watercolour or gouache, then pastels are added on top.

1 Apply a mid-blue pastel on a bright red background.

2 Layer a pale blue on top, easing off towards the top so that the mid-blue and the red paper show though.

3 Layer white at the bottom over the other two colours. Vary the pressure you apply. In places the red shows through, in others it is now obscured by layers of colour.

The finished layered effect.

Scumbling

Where two colours areas meet when blocking in, the edge can sometimes be too hard. Since no detail or specific shape is needed at this point, the edges can be softened by scumbling; gently scrubbing the two edges to fuse them together. In later stages, when detail is applied to specific shapes, this softening of edges is often useful to connect the subject to the background, giving it 'lost and found' edges which help the viewer's eye to see the entire composition as one. This is an especially useful technique near the final stages of a painting, for softening edges to avoid too much detail.

1 Block in an area of yellow on a red paper background.

2 Block in blue next to the yellow.

3 Use the yellow pastel to drag colour from one side to the other, creating a lost edge.

The finished effect.

This sketch was achieved in twenty minutes before the rain came, using dry techniques. Glazing was used in the sky area, where overlays of colour suggest the approaching showers; layering for all the ground areas where colour variety is needed; and scumbling, where the rain blends into the mountain and where colours blend in the foreground.

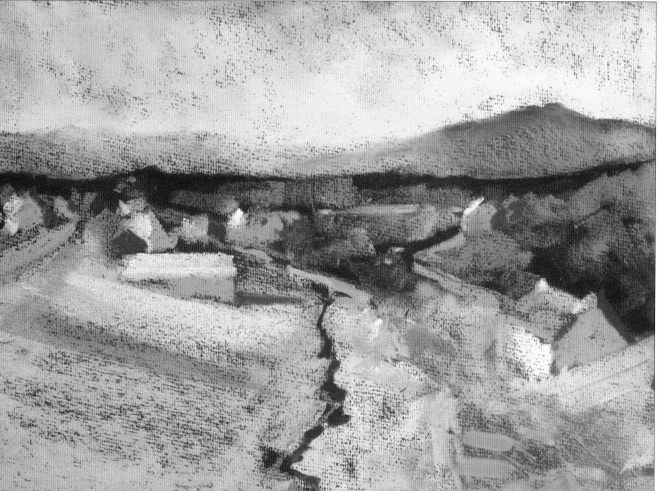

Wet techniques

Although wetting pastels is a relatively new technique, as pastels have traditionally always been considered a dry medium, it is logical that they work with either water or spirits. After all, pastel is pure pigment from which other types of paint are made, with additional wet ingredients.

However, there is always an unknown factor in wetting different brands of pastel, as each brand differs in its proportion of pure pigment content. Some have mostly pigment with binders to keep them together, and others are bulked with fillers like clay, chalk or kaolin. These can sometimes resist wetting, but the results often create surprising, creative results.

When you are using water to wet your pastels, you can use heavier weight watercolour paper as a support. Either use a rough textured paper or apply a layer of transparent gritty primer specially made for pastels.

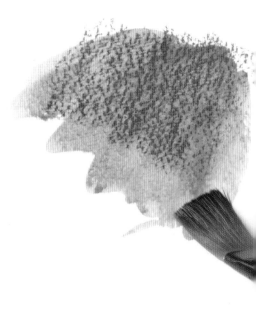

Adding water

Adding water to pastels literally unleashes the colour and adds a totally new dimension in appearance, with fluidity and fusion of the colours. Wet into wet techniques, normally used with watercolour, create movement and flow in the pastels, and colours running into each other can create beautiful textures. Spreading a pastel colour with water can dilute intensity to create tints, whereas simply dampening pastel will intensify colour and make it look like pure paint such as oil or acrylic. After wetting, the colours appear darker, but as the area dries out, the colours will return to their original intensity. Although much of the pastel then becomes fixed, as it has turned into paint, once dried out completely, there is still a small proportion of 'dust' on the surface which will still need either fixative or a covering of glass on the final painting.

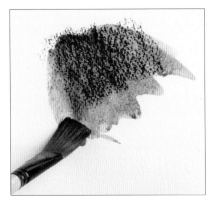

Apply red soft pastel, then use a large flat brush, very wet, to brush in the colour. This creates a wash as shown.

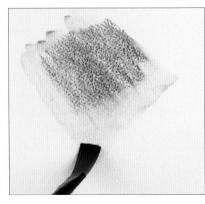

This shows the same technique but on hard Conté pastel. There is less pure pigment and more filler in the hard pastel, so it creates less of a wash. This can be useful however, for instance when painting crumbling old walls.

Paint red and gold soft pastel side by side and brush across both colours with a wet brush (though not as wet as for the previous techniques). This creates intense colour.

Paint a line in a very dark red, then brush it with water to one side. Continue brushing with clean water to create a gradient from dark to light.

1 Apply red pastel, then wet a brush, blot it on a paper tissue and brush it damp over the pastel. This creates intense, solid colour.

2 You can then work into the area with the pastel again, and it will release more colour. Don't put damp pastels in your box however, as they will make the others crumbly.

Caddy Track, Gleneagles

Pastel on white gritted board. I love the wet techniques for splashing on water and letting loose with colour, but they are also very useful when doing tighter work, such as in my golf art paintings where the manicured greens and pathways demand more detail. To create the evening glow of the autumn sunlight, I diluted the pastels after blocking in the initial golden colours of the landscape. This turned the colours into pure paint, killed the white of the paper instantly and created the effect of warmth. The sky has several layers of pastel, with water added to build up the colour, and the distant fields and hills were left with the directional brushstrokes from when the water was added. The foreground and trees required more intensity, which I achieved by dampening the dark pastels after application. This use of a brush could also aid further detail if needed in the branches and trees but I decided I had fiddled enough! Remember that wetting pastel with water will dilute the colour and spread it around like a wash, whereas dampening the pastel will intensify the colour, so different effects can be achieved just by the addition of water.

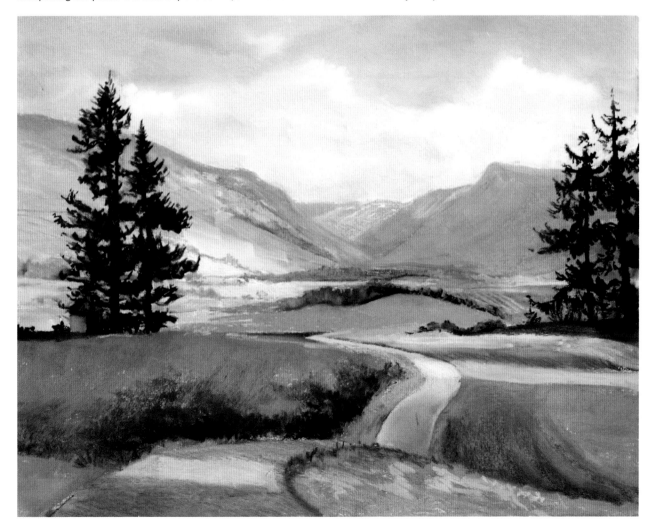

Impasto

Impasto means applying paint thickly to create textural marks, traditionally with brushes or palette knives. The technique can also be used with pastels when they are applied in layers, building up to create thick areas of colour and texture. With the addition of wet techniques, an area of applied pastels can be dampened to create a solid block of colour, then further dry pastels applied on top, creating marks similar to brushstrokes. This is a particularly useful method of building up foregrounds, where textural marks take the place of detail, and create depth in the painting.

1 Paint ochre on top of a pastel background.

2 Wet the area slightly with a damp brush and just catch it with the tip of a bright orange pastel to make textural marks.

3 Spray the area with fixative, not to fix it but to wet it.

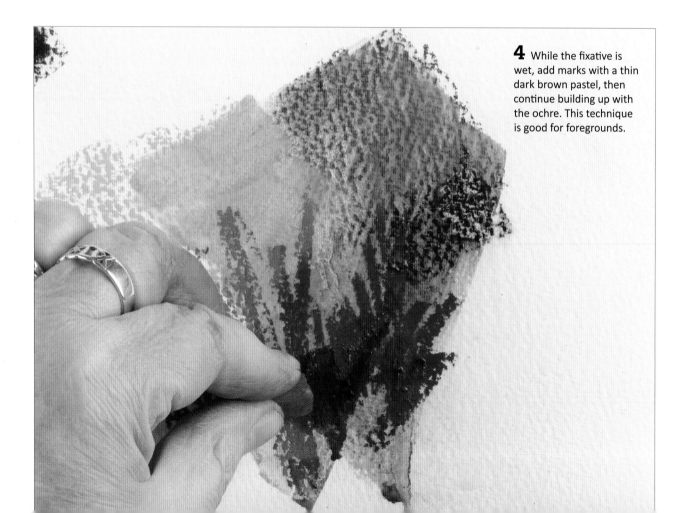

4 While the fixative is wet, add marks with a thin dark brown pastel, then continue building up with the ochre. This technique is good for foregrounds.

Winter Warm

This was painted on thick 300gsm (140lb) Rough watercolour paper and primed with grit primer. The first pastel layers were washed in using water.

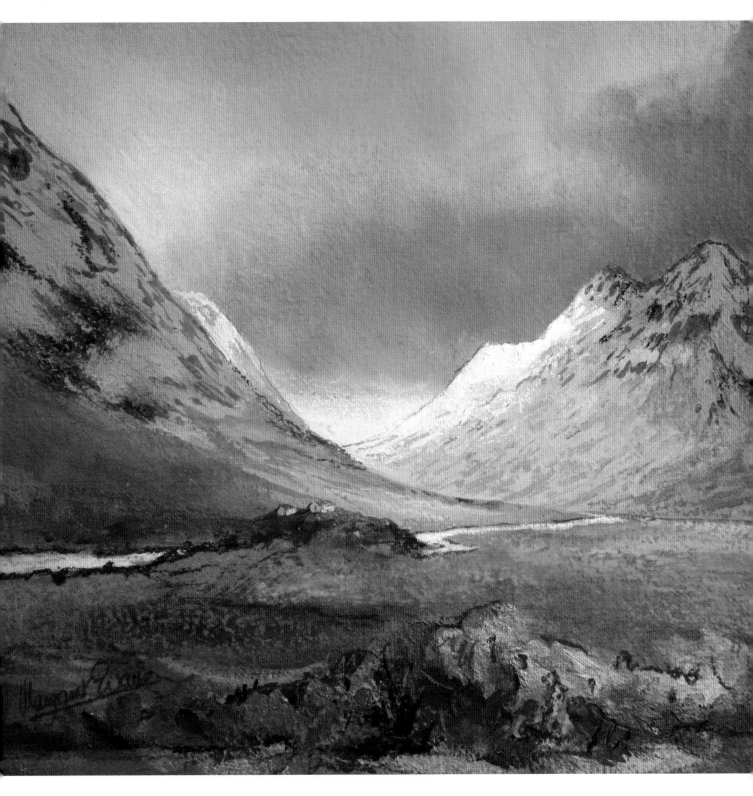

Diluting

Dilutions of colour can be achieved by blocking in areas of dry pastel, then covering with a wet brush to spread the colour over a wider area, rather like watercolours. The wet into wet technique overlays such washes to develop colour mixing and create a transparent effect. Diluting old pastel paintings can be fun, in that the colours can be mingled to create an abstract colourful base, on which a new painting can be developed. I also like to dilute colours in my blocking in stage to help cover the paper colour in areas where it should not be seen.

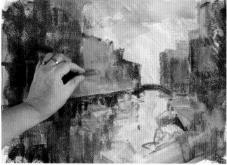

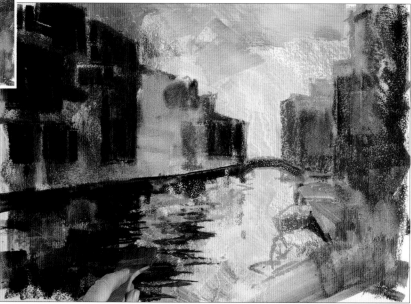

Here the diluting technique was used in the Evening in Venice demonstration on page 104.

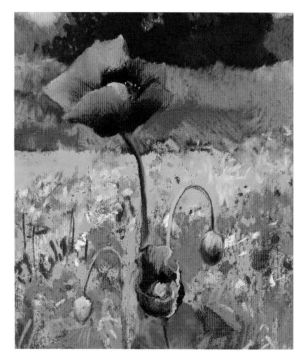

Intensifying

As a painting develops, the pastels are applied thickly in some areas, and thinly in others where the underpainting shows through. Towards the end of the painting, some areas may lose their intensity, either due to overworking, creating too many colours which have become muddy, or simply from dust falling while painting. By dampening this section, then applying pastel thickly on top while it is still damp, you can intensify the colour. This is particularly effective for subjects such as flowers, where strong, vibrant colours are needed (see the detail from *Giverny Poppies*, left; the full painting is on page 143).

Using turpentine and other thinners

When using wet techniques, some artists prefer to use turpentine or other paint thinners such as odourless mineral spirits, alcohol or acetone.

Remember when choosing your preferred method of wetting pastels, the surface must be suitable. Most heavier weight pastel supports now work with wetting techniques without buckling.

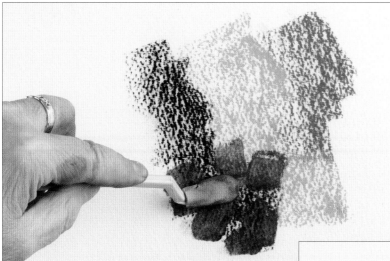

1 Paint on dark indigo, turquoise and purple. Dip a sponge applicator (used for pan pastels) in turpentine and use it to create texture.

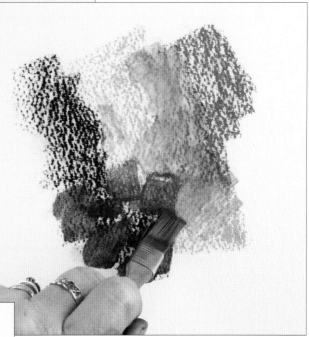

2 You can also apply turpentine with a springy, synthetic brush.

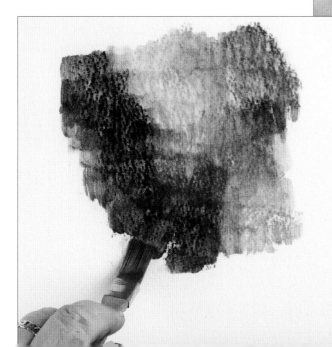

3 Dampen the whole area with turpentine. This is useful for creating a vibrant underpainting.

Glazing

Shades of grey are glazed lightly over one another so that the underlying tones show through.

Layering

Laying one colour on top of another, sometimes showing the under-colours as with glazing, but sometimes covering them.

Scumbling

The edges of two different colours are lightly rubbed, either with a blender such as a colour shaper, or with a finger, to soften the edges together.

Diluting

Diluting colour in skies and distant hills helps to keep these areas smooth, whether using water or dilutants like turpentine.

Intensifying

This is similar to impasto. Colour can either be built up thickly to give an almost three-dimensional effect, or 'solidified' with a damp brush, which intensifies the colour.

Impasto

This is known as an oil painting term, and adding thick layers of pastel on top of each other (sometimes when the under-colour is damp) gives a thicker, painted effect.

Adding water

When colour is applied thickly, a damp flat brush used on top can give the impression of flowing water.

Gathering subjects

Sometimes subjects for painting can be crammed in your head, and you don't know what to paint first. At other times it is more of a struggle to think of what to paint. It is important to paint subjects that are close to your heart, or that you have a particular interest in, as the emotion from an artist can be seen through their empathy with the subject. Travel stimulates the artistic brain and is a great source of inspiration, as visions of colours and patterns, scenery and people in different cultures can stay in your mind for long periods after you have returned home. Once at home, I often see my own surroundings in a different light, which helps me to reassess what I want to paint and how I want to paint it. That is when the discipline of a good sketchbook comes in. My painting diaries record my travels, reminding me of experiences and places, and become a teaching tool for demonstrating to groups. In the workbooks that I develop in the studio, I take particular themes that remain in my head after a trip, and attempt to decipher the elements that captured my interest, and turn them into pictures. This is the first part of the translation of fragments and ideas that make up my inspiration.

My sketches are often worked out in watercolour, as the 'flow' of paint is like an untamed beast that follows your direction, but goes its own way too, resulting in unexpected, spontaneous marks. This element of the unknown appeals to me, and as I sketch, I am already planning the translation of the results into pastel techniques to convey an even greater freedom.

I am therefore never short of subjects and ideas to paint. I also work in themes, so may do a series of paintings of a particular place or subject, which creates an orderly flow in my work, and helps the work to have a connection when the paintings are exhibited together.

Children, pets and new hobbies like gardening may suddenly open up new directions in your repertoire, and it is refreshing and challenging to tackle these unfamiliar subjects, in order to develop a technique which helps to generate your own personal style or interpretation.

It is also important to ask yourself at the start of a painting, 'Why am I painting this? What is it about this subject that inspires me?' As the painting develops, it is easy to go off on a tangent and lose the original inspiration and purpose, making it difficult to decide when the work is finished.

Sketchbooks

It is always a good idea to spend a while planning in a sketchbook before painting. The preliminary sketch is essential for working out the basics like composition, shapes, tone and colour, even if our enthusiasm tempts us 'just to get on with it'. Composing should be uncluttered, balancing large and small shapes, light and dark areas, warm and cool tones, and keeping the intentions clear to avoid detracting from the painting's *raison d'etre*.

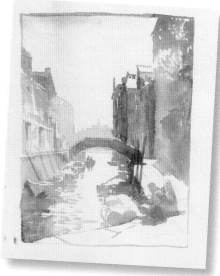

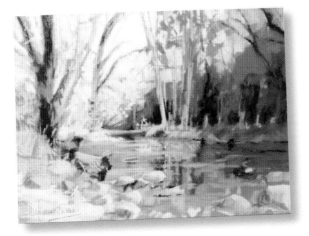

The sketch for the Woods and Water demonstration painting on page 82.

The sketch for the Evening in Venice demonstration painting on page 106.

Our creativity is important: the unique way that the artist can tell the story, rather than just creating a factual image, like a camera. Some artists call this 'visioneering' and others adopt a 'select and reject' process to simplify the details. Creating your own artistic vision allows your personal expression to come through in the work, and helps you to adopt a style which becomes unique. Sketchbooks are ideal as they are personal pictorial diaries where you can develop ideas, exaggerate or imagine colours and distort the truth. One of my favourite quotations is from Ed Whitney, the American watercolourist, who said, 'Don't tell the truth, tell beautiful lies!'

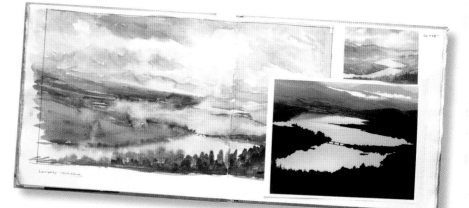

Mists Rising, Glen Garry

My watercolour sketch developed the colours that were missing from the photograph, and I sensed from my memory of the scene that it was purples in the land and warm golden tones in the sky that made it paintable to me, so I used a dark aubergine-coloured textured paper, and developed the palette to emphasise these factors.

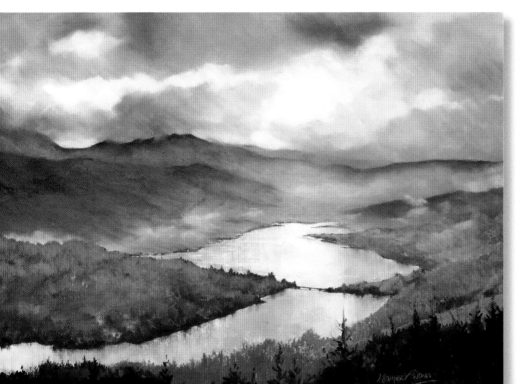

41

Photographs

Although painting outdoors is preferable to working from photographs from an artistic point of view, it is not always practical or possible, and many of my finished paintings begin from photographs. The next pages will explain the importance of workbooks in the artistic process when using photographic reference. For every scene painted indoors, I use several photographs recording different moments of changing light and different angles and viewpoints, and during every outdoor session, I take numerous photographs of subjects I don't have time to paint. Some are even taken from a moving car (though not while driving of course!) and others are impromptu opportunities that crop up in a flash and have to be photographed quickly.

A good example of this is my Amish series, where photographs had to be taken surreptitiously as subjects did not like being photographed.

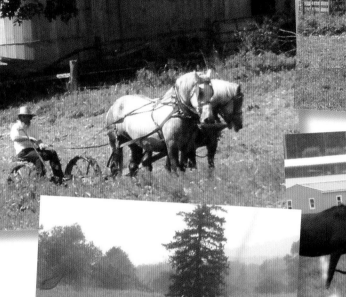

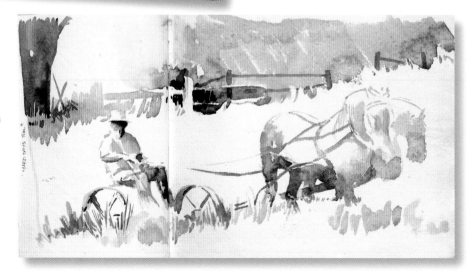

These photographs were taken from afar, from the car or behind trees, as I quietly watched some Amish figures and sketched the scenes. I thoroughly enjoy the observation of such interesting cultures when travelling, but appreciate and respect their need for privacy. I hope the paintings simply record factual life styles – people are a great source of inspiration.

42

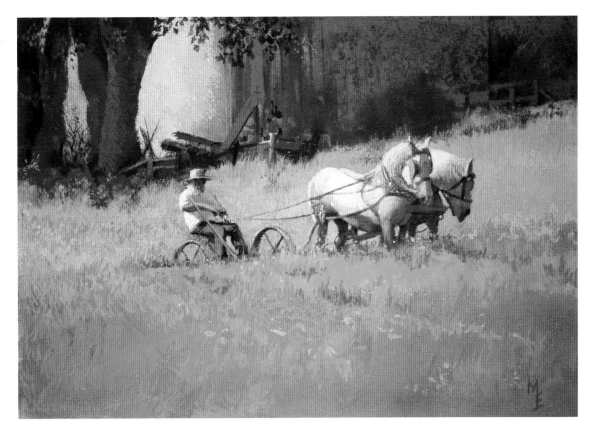

Hard Day's Toil

This farmer was a long distance from me, where I was parked by the side of the road,
sketching the setting. I took lots of photographs as he worked his way down the field,
but shortly afterwards, he turned to come back up, saw me and started to shake his fist.
Needless to say, I stopped, and dashed off!

Time for Work

I was painting the Amish farm scene at right angles to this with my group, when this young lad
emerged from the house, followed faithfully by his dog, and sauntered over the field to collect
one of his horses. I clicked away with the camera as he tethered the horse and led it back
towards the carriages parked in the farmyard. This event alone was worthy of ten paintings!

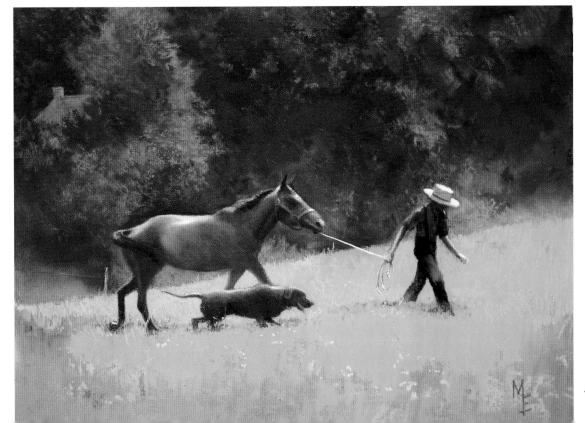

43

Workbooks

The use of photographs is popular among artists for convenience, and it is not to be discounted as an important means of gathering subjects. However, if you are working from them all the time, it creates a habit of copying, rather than reinventing composition, and colours become unimaginative. It is more important than ever to develop ideas from photographs in a sketchbook. I use my workbooks, as opposed to my sketching diaries, when I have taken extra photographs of subjects I have not had time to paint outdoors, and I develop ideas and picture plans from these. This is a great way to make unsuccessful photographs interesting. Perhaps the colours came out differently to how you remembered them, or the light was flat, or the composition was snatched in a hurry. Whatever the limitations of the photographs, the creative vision can kick in and start manoeuvring these restrictions to create exciting ideas from which to paint. From one mediocre photograph can come several great ideas for future paintings, through changing colours, tones, and formats. I get a lot of mileage out of one photograph, and over a period of years may return to the same source many times, creating many variations of it.

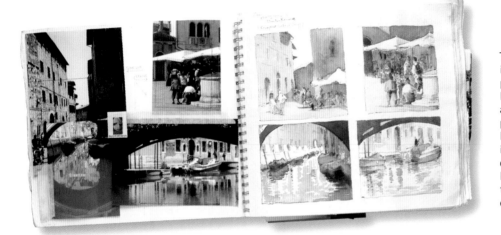

The workbook for the Evening in Venice demonstration on page 106. This was inspired by a series of photographs and sketches which combined people with bridges and boats. From a mixed page of ideas like this, many paintings develop which may end up being completely different to the original subjects and composition.

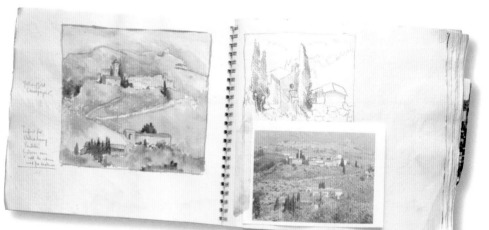

The workbook for the Tuscan Hillside painting on page 94. Sometimes the composition in the photograph can be just what you are looking for. Doing a tonal sketch to work out the light source, and a colour study to experiment with the desired mood helps you to understand exactly how to go about the subsequent painting.

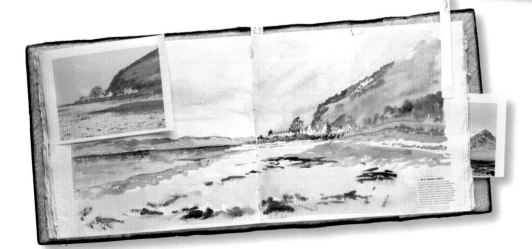

The workbook for the Coastal Scene on page 118 was painted *en plein air*, and already gave me a good lead into how I wanted to portray the scene. The attached photograph was uninteresting by comparison, and I did not need to rely on it for colours and tones.

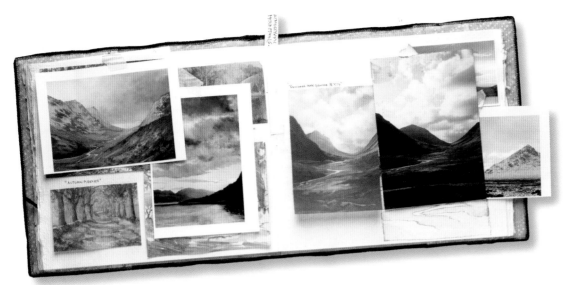

This workbook is laden with photographs and sketches of places around Glencoe and Kintail in the Highlands of Scotland, and it has provided me with plenty of ideas for using the colours and compositions to create new paintings, particularly for the Atmospheric Mountains demonstration on page 70. From photograph to watercolour sketch, the ideas evolve, and when I do a painting from each plan, I print off a small photograph of it and paste it into the same page, to show the route I have taken from the original sketch. Then if I want to do another painting of the same subject at a later date, I have a reference of what I did before so that I can change the format, colour scheme or composition to make each painting individual. The photographs and *plein-air* studies from a passing moment at Loch Garry have yet to be developed, but given the fluidity of the watercolour studies, I am most likely to use wet techniques to develop this into a painting. It is on my 'to do' list!

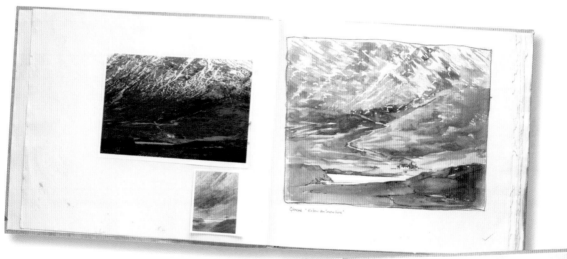

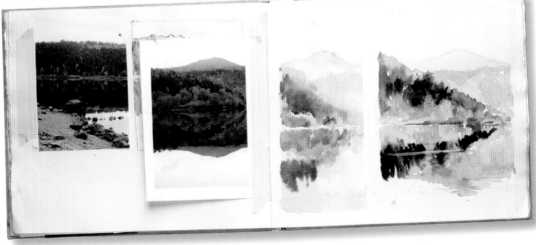

45

The workbook for a painting of the Old Man of Storr on the Isle of Skye has many versions of the scene which have developed into different interpretations of the subject, such as traditional paintings reflecting the true Scottish weather, like *Spring Storm, Skye* (opposite) or more creative and fanciful versions such as *Red Skye*, also shown opposite.

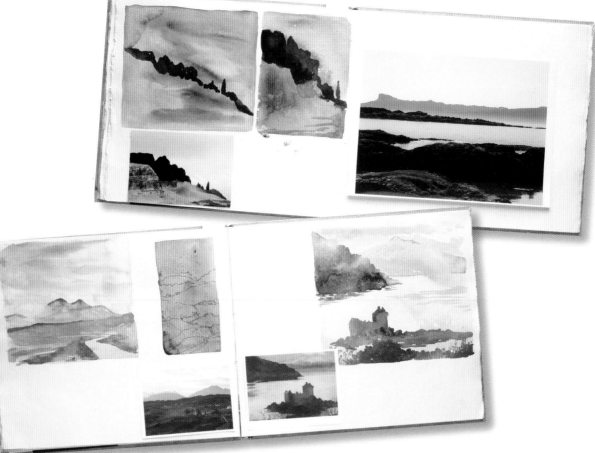

The workbook for a painting of Eilann Donan. This is one of Scotland's best known historical castles and must have been painted by every known artist that has passed it, but I still search for different angles and interpretations of it every time I go past!

The workbook for a painting of dusk along the Skye coast. The Cuillin Mountains attract me from every possible angle, and therefore feature in many of my finished paintings. I put a red dot next to each painting that has sold, to remind me to tackle it differently next time I use the same sketches.

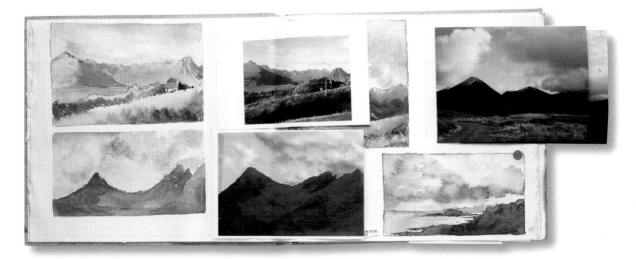

46

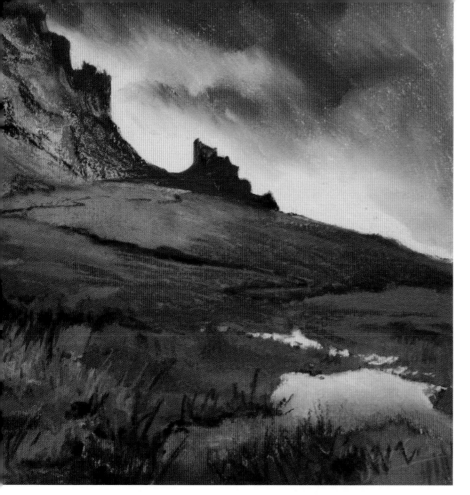

Red Skye

OK, so I was exaggerating with these colours, but so often on Skye you do get these classic moments of 'red sky at night' and I thought I would take the idea a little further. I was also looking for a wedding gift for my god-daughter when I painted this and had a feeling she would like some vivid, funky colours!

Spring Storm, Skye

Returning to the same place to paint is quite common for me, as I am often out researching sites to bring my students to. The Old Man of Storr is a favourite, and never looks the same twice, whether it is midsummer or deep winter. The effect of clouds rolling over these crags is always fascinating, but you have to work fast, both to capture the changing landscape, and because the wind is blowing!

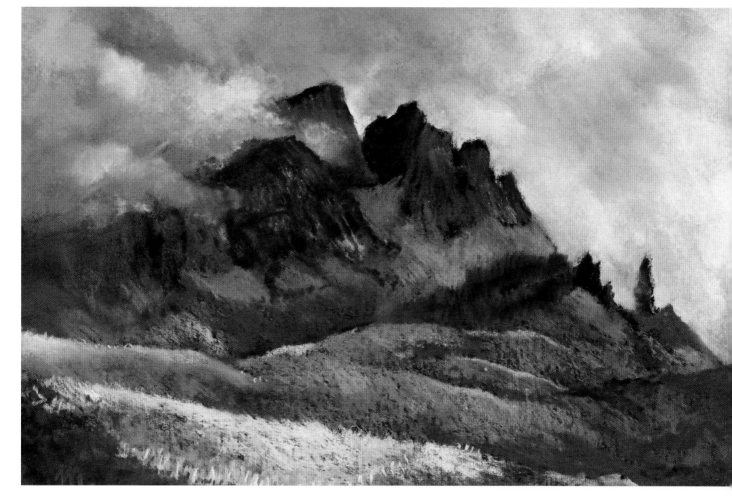

Travels home and away

The first thing to organise with painting and travelling is to simplify the gear you need according to the trip. If you are based at home, but planning an outdoor session by car, it is easy to throw a pile of things in the boot, but even then you will waste a lot of time on arrival, sorting out what to use. It took me a while to realise that half of what I was carrying up hills was never used, and when I returned home, I would create two piles – one with all the gear I used, and the other with all the gear I had just carried up a mountain and back for nothing! My travel boxes are the best organisation tool ever. All the pastels are already sorted out, and my paper is limited to assuming the maximum requirement of two to three sheets per day. These are taped on to a drawing board made up of two sheets of foam core taped together to form a portfolio. My easel and a small stool are added, and apart from layers of clothing to prepare for adverse weather conditions, I'm ready!

I have international travel down to a fine art too. As a pastellist, I accept that inevitably I will be stopped by security, as any number of pastels sitting in a box will arouse suspicion, as they look like rows of bullets! Attach a label clearly stating that they are art materials; specifically artists' chalks (this is the only time I will refer to them as chalks, but most people will understand this description, as opposed to pastels). Be prepared to open the box and show them to the security staff. Your willingness to share your knowledge of the products always helps to ease the situation, and my business card often gets passed over to a new recruit this way!

It is possible to carry the pastels, watercolours, pens and sketchbook in my carry-on luggage without too much bulk. My easel and papers are packed into the suitcase, as they could always be replaced if they were lost, but my pastels are sacred to me, and the sketching equipment is always at hand to scribble down ideas in transit. I have found lately, that my tablet has become an essential part of my kit, and it travels everywhere with me, as it not only keeps me in touch, but takes good photographs and zooms into details when needed.

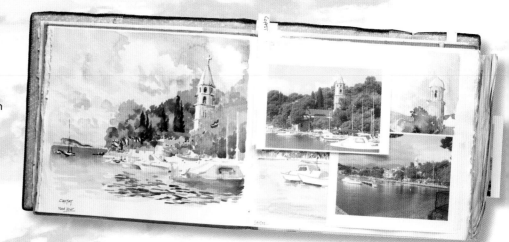

On a painting holiday I encourage my students to develop their sketchbook like a travelogue so that it is not just full of pretty sketches. We try to capture the movement of dancers by paint scribbles, collect and paste in beer mats, cards and menus from places we have been, as well as the classic postcards of subjects and diary notes. These books are not only invaluable as painting reference when you are back in the studio; they also become treasures to hand down to your family. I have a queue of friends and family waiting to inherit twenty-five years of travels!

Places and their influences

Having explained my methods of collecting painting ideas through my travel diaries and workbooks, this is a good point to reflect on how places affect you and what you can do with these emotions. Painting is not mechanical. You can learn all the theory and study different artists' approaches and thought processes to achieve what they do, and you can subsequently practise, practise, practise and eventually perfect the techniques you have studied. But there has to be emotion in the work, where the viewer can not only enjoy the execution of the work, but feel the passion behind it.

This determines the subjects you choose and explains why I enjoy returning to certain places time and time again, never getting bored with the same subject, but feeling energised by the familiarity of a place, and inspired by the endlessly changing faces it offers. For example, my return to Scotland many years ago, to set up our studios at Shinafoot, eventually changed my attitude towards landscape painting, which until then, I had avoided. Although I still enjoy exploring new places, if I want a guaranteed productivity when going out to paint, I only have to head for Glencoe or the Isle of Skye to find plenty of moods in the landscape to inspire me.

Italy has the same influence for me, Tuscany in particular, and my library of sketchbooks offers me endless subjects to paint from previous trips, as do my annual trips to Venice. If you are looking for an artist to study under on a painting holiday, look first at their work to see if it inspires you, but also at the places they go to regularly. Anyone studying my programmes over the years will know that these places hold a special place in my heart, and they feature in exhibitions of my work. Of course, the other elements of surprise, challenge and excitement arise with new pastures, and as I travel to different continents, I also love the new inspirations they throw at me.

Pen and wash is a great way to capture quick studies, like this workbook of sketches of one of my favourite places, Glencoe, which never fails to inspire me. With these and watercolour studies for colour reference, I have plenty of information collected for setting up the pastels once the showers have passed, the winds have dropped and 'serious' painting begins!

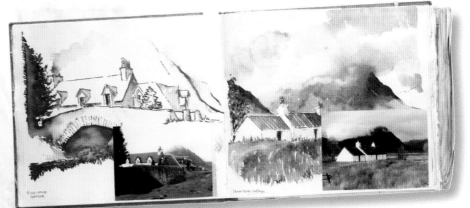

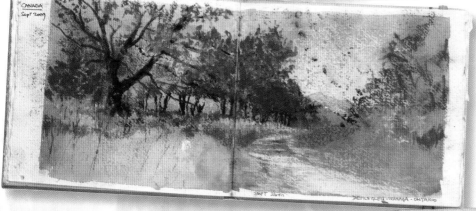

This sketch done in Canada proves not only that it rains in other countries when you want to paint *en plein air*, but also that pastels will actually absorb the wet weather and turn to paint in the sketchbook, as opposed to running off the page like watercolours!

These studies of farm buildings and panoramic views were painted in the Hudson River Valley in New York State, USA, on multicoloured background washes, speckled by the rain. As anyone who knows me will tell you, I don't let the rain put me off *plein-air* painting!

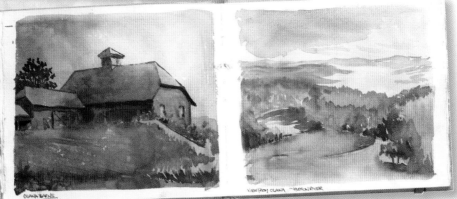

When sketching on site, I favour stitched workbooks, as opposed to spiral-bound, as I can work across the spine and create a double-page spread. This gives me scope for further compositions later on, and from the format shown here, of Gozo, Malta, I painted *Inland Sea, Gozo*, shown below. The photograph of the painting is taped into the corner to remind me again of the composition, so next time I use this study, I may paint the panoramic version.

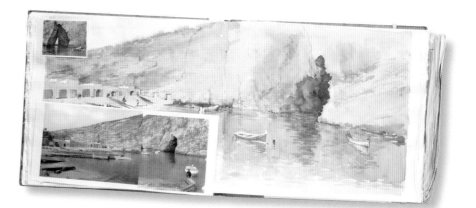

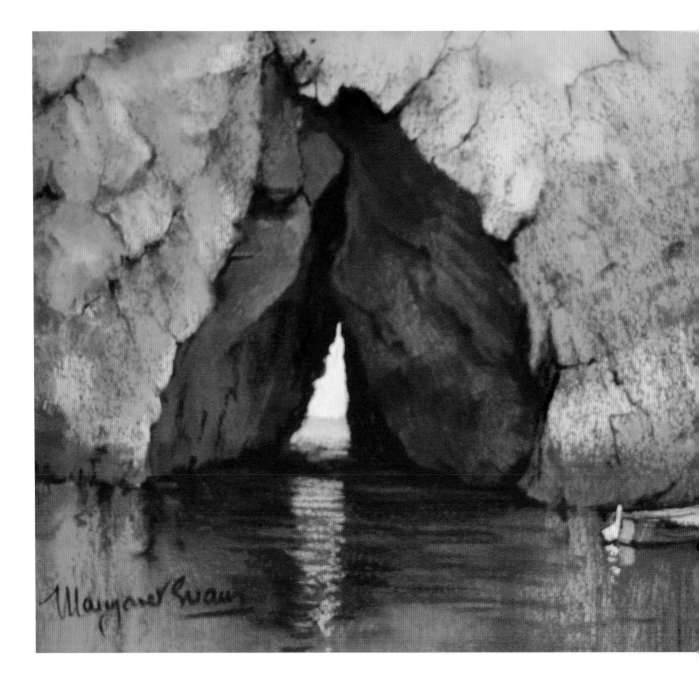

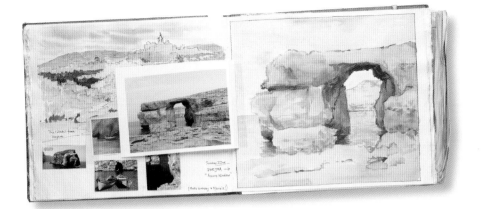

Further sketching in Gozo attracted me to the 'Azure Window', which is always busy with tourists. Happily painting among my painting group, I produced a good watercolour, which inspired this wet pastel version, *Azure Window, Gozo*.

Inland Sea, Gozo

Other sources of inspiration

Apart from travel, inspiration can come to you through your stages in life and offer new challenges along the journey. My early years at Art School developed my love of portraiture and figure painting, through the life classes and the tutors I had, who were eminent portrait painters in their own right. This continued in later years when my family were growing up. There is nothing better than a cute child to make you want to be able to paint faces, and no doubt this continues once grandchildren come along! Landscape painting did not enthuse me until I returned to Scotland, wanting to teach painting, and quickly realised that most people wanted to learn outdoor painting and landscapes. It is always daunting to start new subjects. I couldn't paint dogs and cats until I owned pets, and later, when teaching in India, I was asked to demonstrate painting elephants, so I had to quickly adapt the same principles I used for other subjects, take a deep breath and go for it!

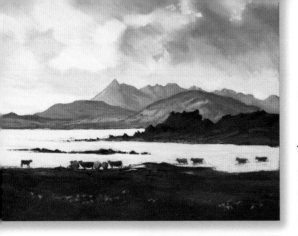

Composition

Whether working outdoors or indoors from photographs, the planning of the composition is important, and it is worth taking time to consider the options. Remember that a landscape subject need not always be painted in a landscape format, in the same way that a portrait need not always be portrait format. Each time you assess a new subject, it is essential to look at the 'bigger picture' and work out how it can best be contained. Although photographs are already composed when they are taken, the composition can be reassessed. One good photograph can offer you several choices, each worthy of a painting, perhaps developing a different focal point or mood.

Bear in mind the different formats the artist can work in (see examples, right). Panoramic or square compositions can be more challenging than the usual landscape or portrait. Looking at the subject, I select the extreme points I want to include in the composition, which I call my compass points: the most northernly, southernly, easterly and westerly points. Once these are chosen, I see immediately which format will work best for my painting. Sometimes I use a frame I have used before, when starting a new painting, to challenge me to work in a specific format and size.

Using thumbnails

Thumbnail sketches are ideal when you need to work out composition choices quickly. Keep to tonal studies in pencil, pen or dark pastel. Restrict them to the large shapes in the composition and you can quickly see how the design will work out, and which sketches work. Thumbnails help you to assess the proportions of the subject, as you will see that some work better than others and create a feeling of balance and space.

Working on site, it is always worth taking five or ten minutes to plan at least two thumbnails, one as a landscape format and another as a portrait. In the first thumbnail (left) done on the island of Iona off the West Coast of Scotland, with one dark soluble pastel pencil, I used the portrait format to see if it gave extra depth to the layers of rocks, and the extended beach. I hoped to make the viewer want to walk along the shore by exaggerating this. My first preference is the landscape format, but I just wanted to check out the alternatives. Very often, this time taken to explore the options will give me different compositions for future paintings, as I often paint the same scene several times, making the colours, tones and composition different each time. This portrait format did create an exaggerated 'walk' along the beach, so I may use this for a painting in future.

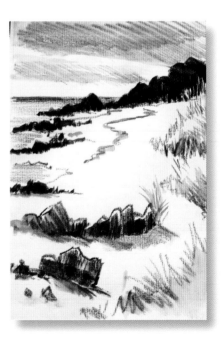

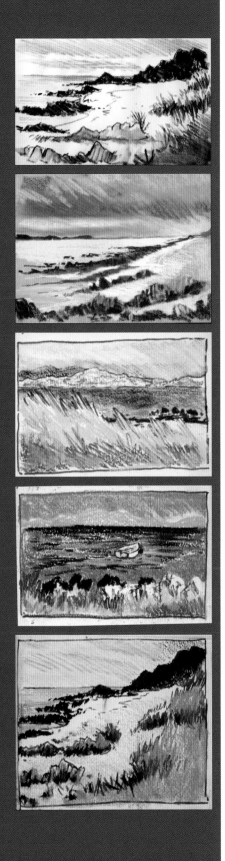

In the landscape format (left), I particularly liked the width, allowing me to show the great expanse of the beach, and for this reason, this is my preferred choice. It is important to try these options out, but also to ask yourself what attracted you to the scene in the first place, and which option conveys that mood best. I knew I wanted to develop this in the landscape format, so quickly set out the same main shapes of rocks. I now had a little extra width to introduce more of the grasses at the side, which I feel enclose the beach and make it even more personal. Iona is a very special place – cars are not permitted on the island without permission, so I was keen to show the serenity and unspoiled nature of the location.

Having decided on the landscape, I switched my viewpoint to take in more of the rocks, sea, and distant land, missing out the grassy dunes. I prefered the other composition, but varied this out of curiosity, and to study the colours in the sea and sky. There is always a fast-changing sky in Scotland, and the artist has to work fast, so quick sketches like these are ideal to capture the moment and the mood. This colour sketch (left) was done in ten minutes, as there was a storm approaching. A little box of Conté hard pastels was ideal for this. I quickly overlaid colours to create approximate colour mixes, with no time for blending, creating a rough but lively sketch.

Although it was tempting to continue with a painting of this planned composition, it was worthwhile exploring more, while the light was dramatic. You can always save these further sketches for working back at the studio, and it will keep your enthusiasm at a peak. Remember to back up your plans with corresponding photographs, to help capture the moment, along with with your fresh, spontaneous sketches.

The changing light on the sea caught my eye as I turned around to look the other way and I made a quick colour sketch (left) to remind me later that the land across the water was very light and pink in comparison to the rich dark greens and blues of the sea; and the distant mountains repeated the dark blue fading into the lighter sky.

Without moving from my position, I saw another potential subject as a little boat started to bob about on the water (see left). The inky deep purple of the sea is what caught my eye, showing up the intense turquoise nearer the shore, and I added a few dark Ionic rocks to strengthen the colour comparisons even more.

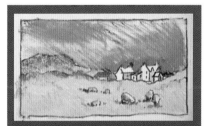

Looking inland, the cloudy sky was brewing into a storm and the little white cottages stood out and caught the eye (see above). Sheep can always be moved later but right then, they were grazing nonchalantly while the weather deteriorated and I seemed to be the only one who was rushing to finish what I was doing!

Back to the beach, but sitting in the haven of the car now, I made a final sketch (left) in a squarer format. The beach scene seemed lighter and calmer as the storm was passing overhead.

All of these sketches were done either with a soluble pen or a soluble pastel pencil, which create quick line and wash sketches to lay in the tones, and the colours were added with a small pack of hard Conté pastels. This kind of lightweight pastel equipment produces quick impressions of a scene that offer me numerous possibilities when I return to the studio back home (see the finished pastel painting, right).

Iona Beach

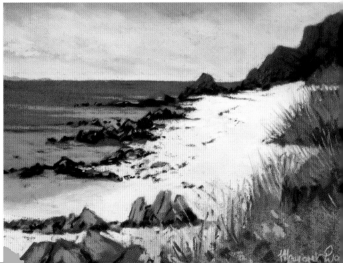

Planning ahead

When composing a subject, it is important to know the perimeter of the composition in order to place it well on the page. Simply starting at the top and working down is not good enough planning – how many times have you ended up with too little or too much foreground when composing like this? My theory is that when starting off a painting, you must look at the big shapes. If they fit well into the picture area, the smaller shapes will fall into place around these. For example, if you are painting a portrait and you start with an eye and work out towards the perimeter of the figure, the head can eventually become badly placed and off balance, whereas by sketching in the outer head shape to begin with, you can immediately see if the main shapes sit well on the page before proceeding on to the features.

Composing with tone

Tonal sketches are quick and easy to do and immediately show up any weaknesses in composition, balance and design. For example, when working out light patterns against dark shadowed areas, the balance can be lost by having too much dark on one side of the picture, rather than playing with light and dark integrations that help the tones distribute themselves better.

In order to compose with tone, the artist needs to view the scene, start from the obvious composition, then look for the alternatives. In this sequence for *Into The Light, Venice*, I started with a simple tonal sketch which divided the composition into dark and light (below, left). This format concentrated on the bridge which caught my eye because it was so dynamic with it's *contre-jour* (against the light) effect. By simplifying the shapes, I could see that the bridge linked the two sides together – often normal street scenes don't work because the shadows are all on one side, but the bridge helped with this problem. However, when I extended the composition, in the watercolour sketch (right), to try a long portrait format, I realised that the reflected shapes enhanced the subject even more, giving a balance of darks and lights playing opposite each other. By the time I was ready to paint the long pastel painting, I had the dark tones firmly in my mind to simplify the composition, then had fun adding the colours! The finished painting is shown opposite.

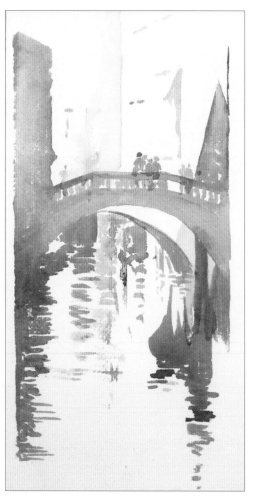

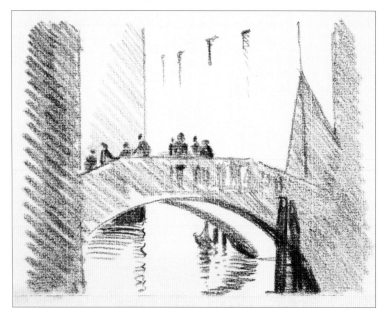

Opposite

Into the Light, Venice

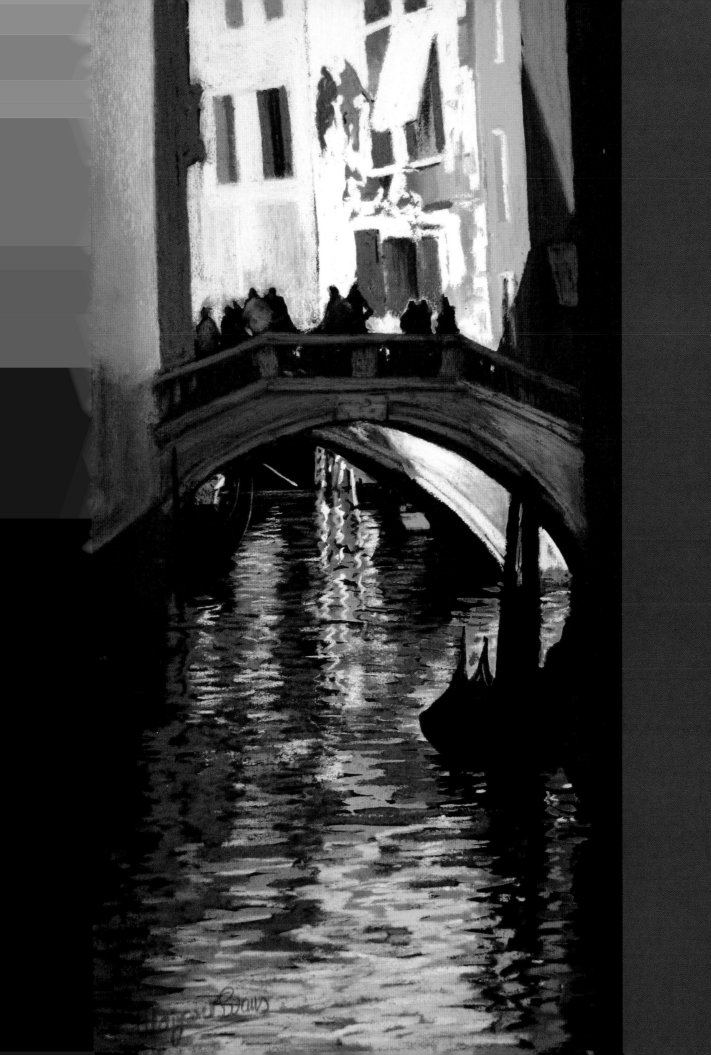

Composing with colour

You can plan composition in a free and liberal way by splashing on colours randomly, allowing them to integrate naturally and seeing how the balance works out. With a limited colour theme, the positioning of different colours will work in a similar way to tone, as light and shade can be represented with warm and cool colours. Predominant colours should be well distributed around the composition to create the best use of space.

In my Glen Garry Reflection series of sketches, I used watercolour to play with some fairly boring photographs that had disappointed me. When you use watercolour for sketches in this way, you can lay the colours down randomly, allowing them to mix, run out of control and create new colours, pools and puddles.

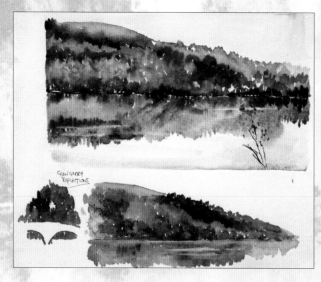

On the left are several watercolour sketches done in this way. You can paint the same hillside several times and it turns out differently every time because you are 'unleashing' the colour, and letting it do its own thing. The tiny sketch on the bottom left shows how to drop colour around a shape such as a house, leaving the white shape so that the house appears and all the random colours surround it.

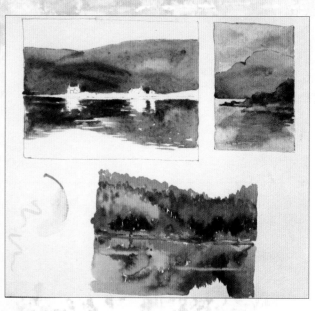

For the sketches on the right, I decided on the colour schemes before I started, choosing to create a golden yellow scene, for instance, or a green scene. The composition is balanced by leaving the less important areas white, creating strong negative shapes with the colours. This approach helps you to decide on the distribution of busy and quiet areas in your compositions and to avoid overcrowding them.

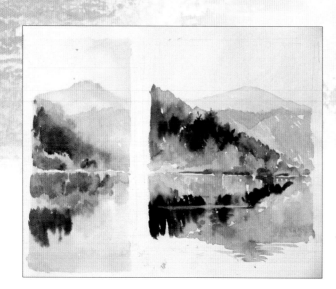

In these colour sketches (left) I have gone for two very different moods: one is warm to depict a sunny, hazy scene, while the other creates a wider tonal range using one colour, which can also be dynamic. Using this version on various colours of papers will create stunning effects and varying moods to your compositions.

These three studies have been worked in pastel from the sketchbook material, developed in different styles to explore their possibilities as full-scale paintings. There are two versions of my interpretation of the top sketch on page 56. Study 1 is painted on a very rough watercolour paper which has also been treated with a coat of gritty primer, making it rougher still. Using water on the first layer of pastels, I let the colours run like watercolour, then work into this with dry pastels to create the layers of trees. Study 2 is painted on to gritted pastel paper, which is also rough, but more like fine

Study 1

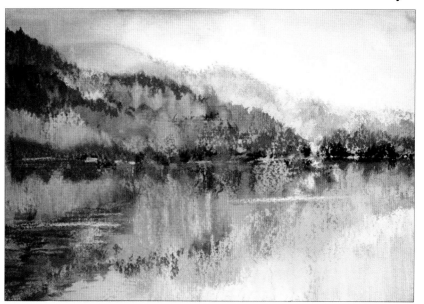

sandpaper, so the colours, when wet, run in rivulets down the page, creating different shapes. I have saved some of these random shapes, and softened a few others with dry pastels again, making a totally different mood. So many different ways to use a sketch! I prefer the second study, which is softer and depicts the tranquillity of the scene more. I am likely to repeat this process in different colour interpretations in the future before deciding on the best way forward.

Study 2

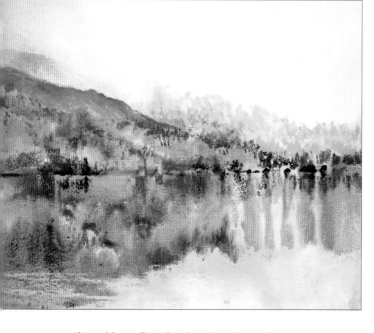

Study 3

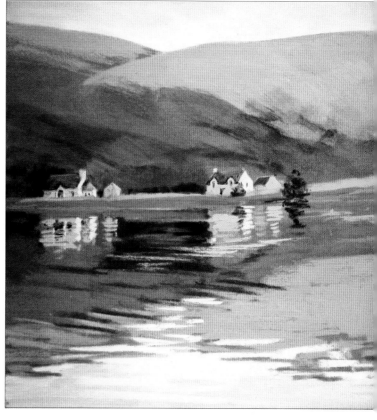

This golden yellow sketch, with outlines of cottages, provided a wonderful evening light over the hills at sunset. This was painted entirely with dry pastel on a pastel card which cannot be wet, therefore the dry solid colours were bolder and simpler shapes, creating a surface like broad brushstrokes. I prefer the square format to the landscape as it accentuates the importance of the cottages. Again, I would develop a few more studies of this subject before deciding on my approach in a painting. By the time I have painted from these studies, my humble sketchbook will have given me lots of mileage and helped me to develop my ideas!

Perspective

A simple understanding of perspective and awareness of eye level is a good start in making your paintings look convincing. No matter how loose and free your style becomes, a simple error of perspective will show up as a weakness and this simple knowledge will also help composition to look effective and convincing.

Basic perspective

Autumn Puddles

The most basic rule for a quick reference to perspective is to establish the eye level right from the planning stage. This will help when putting in any receding roof lines, as they always slope towards the eye level. Also, if you are high up, looking down on your subject, the eye level will be high, and most of the content you are going to fit in will fall below it.

In *Autumn Puddles* (right), the eye level is where the distant trees meet the distant fields, a third of the way down the painting. The verges and stone walls on either side of the painting slope upwards towards the eye level line and the tops of the tree trunks where they divide into branches slope downwards towards it, creating a pleasing composition.

In *Above Tuscan Mists* shown below, the perspective is more unusual. I am at the top of a hilltop village looking down a stairway; therefore I am aware that my eye level is approximately in line with the distant village, and most of the detail is below my eye level. The only receding roof line is the one to the extreme right of the picture; therefore it must go up towards the eye level. The tricky part is that, although the stairway is going downhill, it is going away from me; therefore the edges must slope upwards toward the eye level! Sometimes you have to argue with logic!

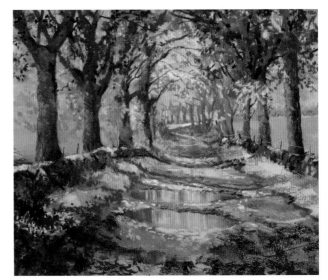

Above Tuscan Mists

Adding dynamics

You can exaggerate the perspective of a scene in order to create a more dynamic, dramatic painting. Most of the subjects we choose to paint are observed from street level, with the majority of the buildings' receding lines above our eye level, therefore sloping down as they go away from us. If you seek a higher eye level, by climbing a hill or looking down from a high window, the angles are exaggerated, and therefore create a much more dynamic perspective. Alternatively, when standing among mountain ranges, although the peaks maybe be approximately the same height, they will be lower as they go into the distance, appearing smaller in scale, and giving a dramatic feel of height, as many of my Glencoe paintings do (see page 80).

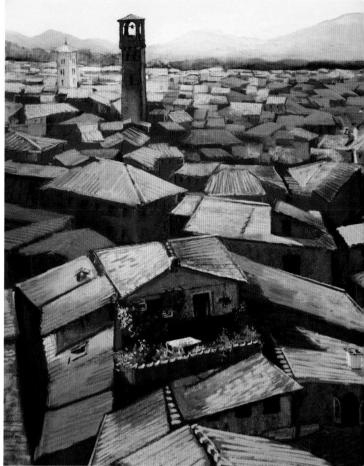

In *Rooftops, Lucca*, the eye level is established high on the horizon, leaving three-quarters of the picture area for the jumble of juxtaposed rooftops, which level out as they rise towards the horizon. The foreground rooftops are placed at sharp converging angles to take the viewer's eye towards that horizon.

In *Shaft of Light*, shown left, the angles on the corner of the building and window rise as they go away from the viewer, creating the feeling that we are looking down on the scene from a higher window.

Shaft of Light

59

Aerial perspective

Aerial or atmospheric perspective refers to the distance between the viewer and the landscape and is essential to create depth of field in landscape painting. The artists is working on a two-dimensional surface, so must consider ways of creating depth to achieve three dimensions. Tonal values and contrasts are essential to create depth, and colour temperature changes will help this. A general tip is that colours become cooler and paler as they recede, although these general rules can be broken and the painting can still succeed; for example in sunrises and sunsets.

In *Pienza Patterns*, shown here, the high eye level where the fields disappear into the background accentuates the atmospheric perspective of the scene. This is further enhanced by the street far below, which meanders into the distance. The tones in the foreground are darker and the colours warmer than in the hazy, cool distance.

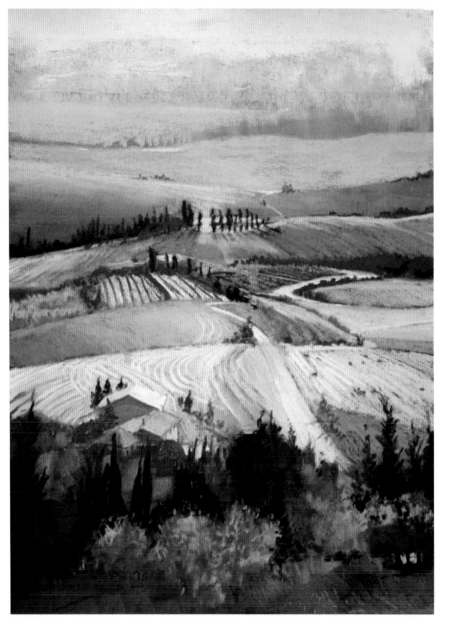

Pienza Patterns

Contrasting angles

I chose these two paintings to show how exploring both looking up at and looking down at subjects will add interest and variation when handling perspective. In *Bathers, Santa Margherita* (right) we are looking down on this subject. The angles of the sunbeds and foreshortening of the figures help to accentuate the high angle from which they are observed. The dark tone floats across all the sunbeds to create intensity in the shadows, and the contrasting bright lights on the beach also create the effect of a hot summer day.

In *Red Wash Day, Venice* (below), the strong angles of the rooftop and windows justify the low eye level this time, showing that we are looking up at the subject, and making the drama of the washing much more interesting. The bright colours of the building against the deep blue sky help to create the heat of the day.

Rather than getting bogged down by technical jargon when painting perspective, simplify matters by asking yourself, 'Am I looking up at or down on my subject?' This will establish whether your eye level is high or low, then angles, as they go away from the viewer, will either go up or down to meet the eye level. Remember the advice K.I.S.S? Keep It Simple, Stupid!

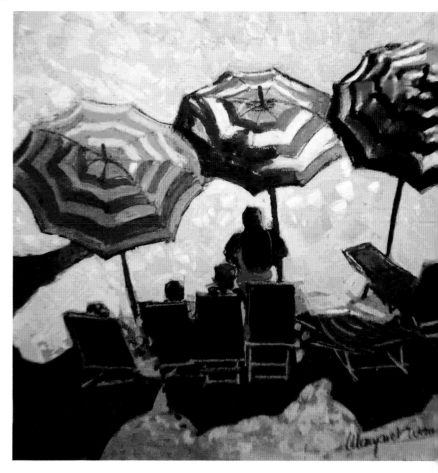

Bathers, Santa Margherita

Red Wash Day, Venice

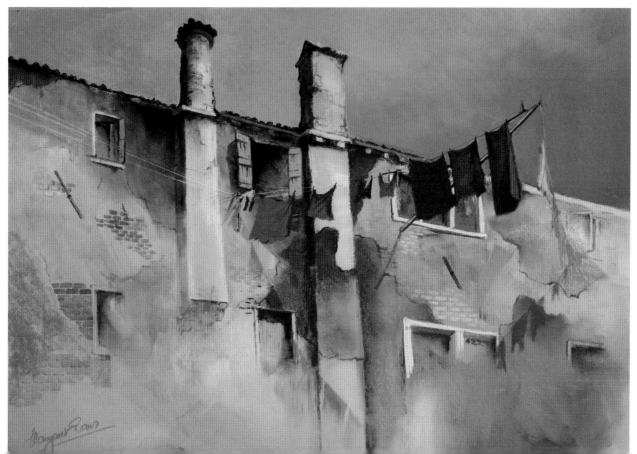

Mood and atmosphere

When planning mood or atmosphere in a painting, pay particular attention to considering the tones and colours to be used. You can create a soft, misty atmosphere by pre-selecting a limited palette of colours, putting the pastels aside on a small tray and seeing how they will go together to create the desired effect. By working with this limited colour range, you will be able to maintain the mood. Also, priming your painting board with a strong colour can influence the development of the painting, and maintain the mood.

Kintail Mists

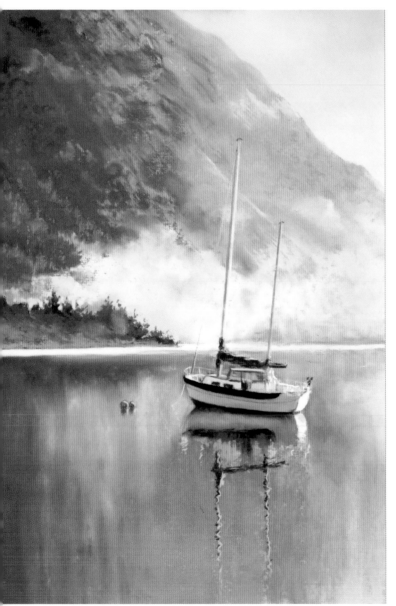

I like to ensure that the balance of warm and cool is considered, even with these limited palettes. In *Kintail Mists*, shown left, the mood is created by pre-selecting subtle shades of blue, to harmonise, but within a narrow tonal scale. However, the little dashes of orange in the water just add a speck of warmth, to balance all the cool shades of blue.

Rising Mists below shows the same scene on a different day and reflects a slightly warmer mood, with pink coming in from the top right and reflecting in the water. There is a wider tonal range here, but I have still kept to a limited palette and soft edges.

Rising Mists

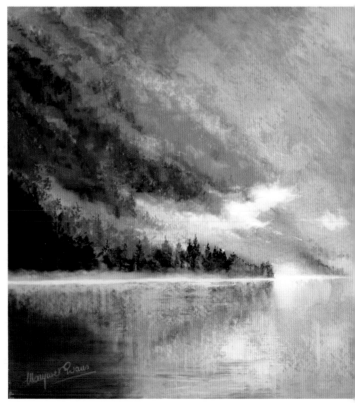

Ice Flow, Glencoe

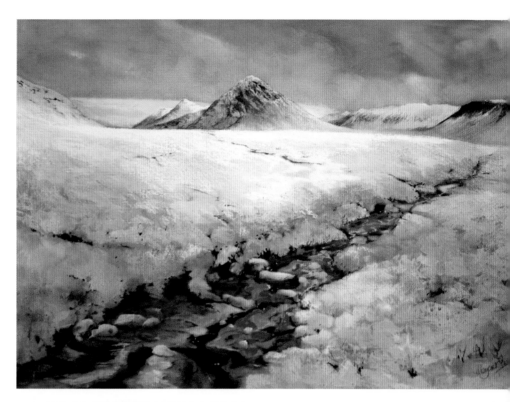

In *Ice Flow, Glencoe* (right) I wanted to create the cold mood of winter in this huge empty landscape, therefore the emphasis is on the tonal range, widening from almost black in the river to off-white snow with tints of colour. However there is still a range of soft colours, proving that there is no such thing as black and white in an artist's palette!

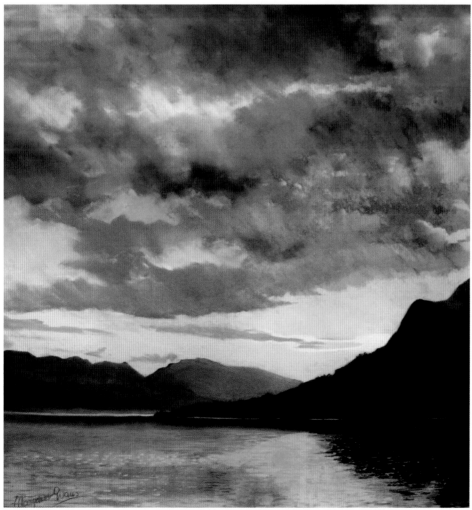

Clouds at Sunset (left) emphasises the strength of sunset colours, balancing cool blues with warm oranges. The range of tones is much wider than in the other examples, and the mood created is quite different. By pre-selecting your palette, you will see from an early stage what mood you are going to create. Have fun experimenting!

Clouds at Sunset

63

Figures and animals

To keep figures 'unleashed' and free, see them as abstract shapes, and allow the imagination to decide who they are and what they are doing. Start with a Conté stick or pastel pencil and simply doodle some stick figures to begin with, varying the thickness, height and proportions to create little crowd scenes.

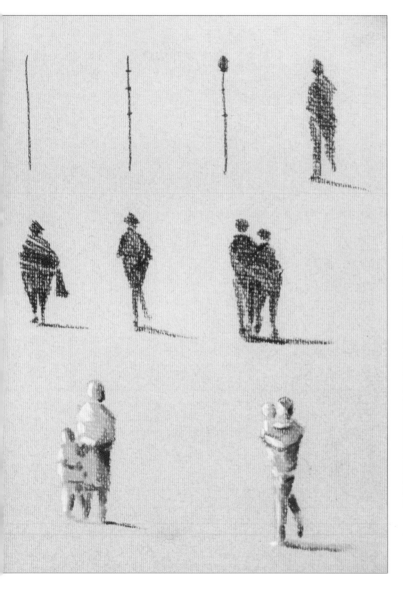

Most of the time your figures will be placed either against light or dark backgrounds using the counterchange technique, so keep them simple. Use one colour, then develop into light, mid-tone and dark to create depth.

From these doodles the imagination is free to create people and groups, and dashes of colour come next. Make up the personalities of the people as you go, but keep them loose and imaginative, without features or details. You will have lots of fun making up little conversations going on between them!

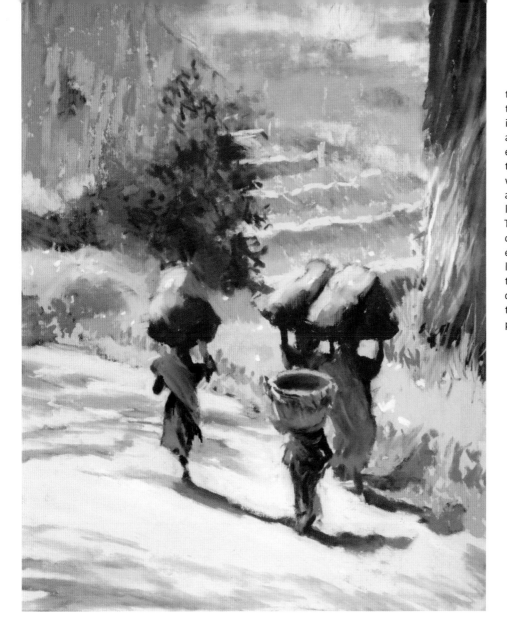

By the time I am ready to build a scene around the figures, my imagination is already filling things in around them and the rest is easy! I painted the figures in this painting, *Indian Carriers*, with as broad a pastel stick as I could, to keep the effect loose and without detail. The scene was set with soft colours throughout to give everything an 'out of focus' look. However, it is still clear that the figures are walking down a country lane between terraced fields, carrying heavy packs on their heads.

In this painting, *Monet's Bridge, Giverny*, the setting was an amazing riot of green, so the refreshing splash of red from the figures was a welcome break! Besides, in such a busy place, constantly buzzing with tourists, it didn't seem right to have nobody there, so this was a perfect opportunity to put in some suggested figures. Anonymity is important, so don't add faces or details, just a hint of a smooching couple among the others to turn this overtly green scene into a fun story!

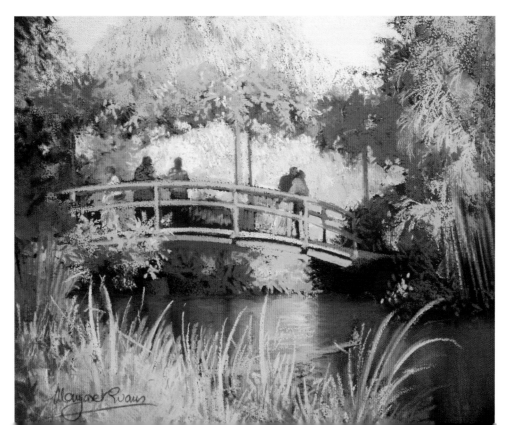

Head to Head, Venice

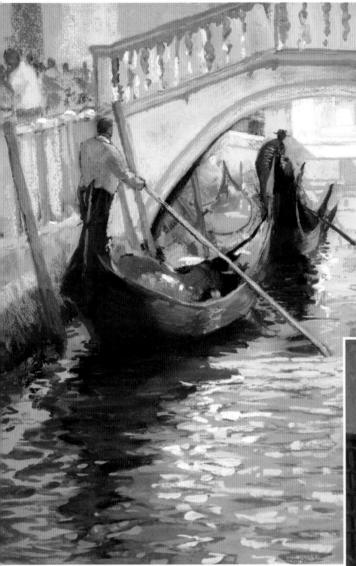

In Venice, the canals are a wonderful source of painting inspiration, but they would look much too empty without some form of life, as this is such a busy location in all seasons. In this painting, *Head to Head, Venice*, a passing gondola and the hint of figures along the bank create a sense of bustle.

Venice Nights

By contrast, this Venetian night scene *Venice Nights, 3* just hints at a solitary couple lurking in the shadows.

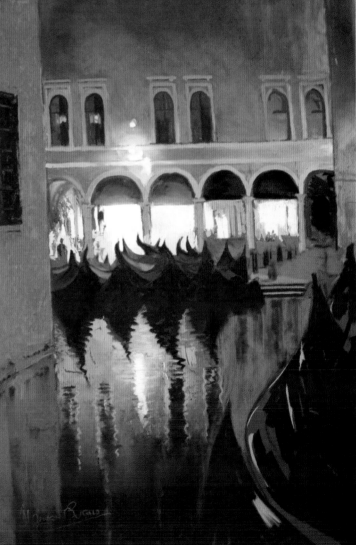

These figurative paintings, *The Big Sleep* (below) and *Step to Step* (right), both move towards portraiture, but rather than make them personal, the space surrounding the figures is loose, applied by adding water to pastel to create a fluid background. I then built up more detail in the figures, without too much showing in the features. I treat this as more of a 'conversational piece' than portrait as it appeals to anyone, rather than just the people who know the subject – much less pressure and more freedom than doing a full-on portrait!

Step to Step

The Big Sleep

As your figures gain momentum, you will be tempted to try portraits of people and animals. By keeping the same freedom and looseness, and avoiding too much detail, a sense of movement will be achieved, as in the loose study *Sheepdog* below, or *Sheepdog Katy*, below right.

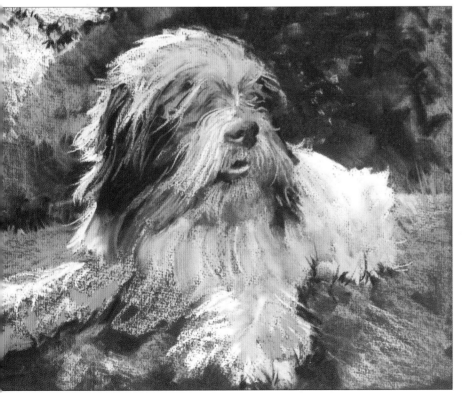

Sheepdog Katy

Sheepdog

67

Demonstrations

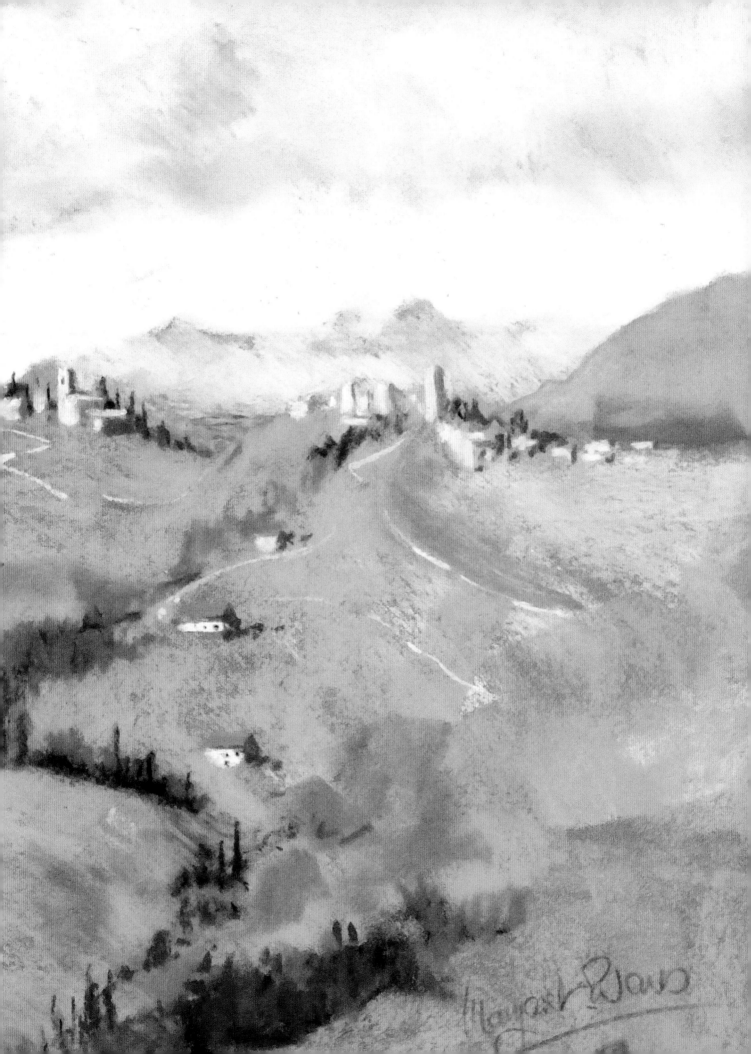

Atmospheric Mountains

Mountains are always dramatic to me, the way the clouds are drawn towards them like a magnet and the light changes rapidly, and the continual changing of contours as shadows roll past. This version of Glencoe shows a brief moment in the life of this great glen, because by the time you capture it, it has changed, and you just want to start afresh, and do it all again in a different mood! Painting *en plein-air* here is challenging, as the wind often blows, any nearby rain is drawn into the glen, and if the weather is warm and sunny, the midges may be out to get you, so you have to work hard and fast, making 'suggestive' marks to plan compositions and keeping it fresh and spontaneous.

You will need

Raw sienna sanded paper

Soft pastels: dark brown, white, pale blue, dark indigo, raw sienna, neutral grey, mid-blue, turquoise, pale pink, rusty red, soft brown, yellow ochre, purple

Hard pastels: pale blue, white

My choice of pastels for this painting. Choose your pastels and put them in a tray like this or something similar, lined with kitchen paper, so that they are to hand throughout the painting process.

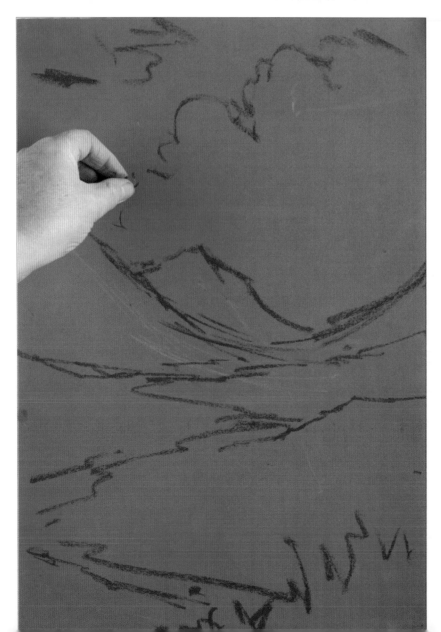

1 Use the tip of a dark brown pastel to sketch in the shapes of the mountains and the water, the grass in the foreground and the cloud edges.

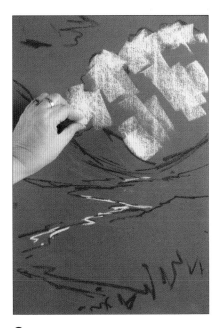

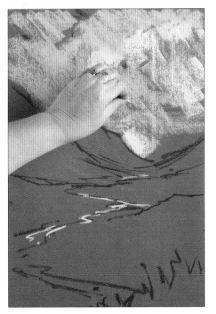

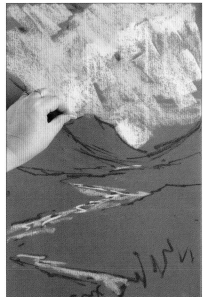

2 Use a white pastel to block in the lightest tones: the clouds and the highlights on the water.

3 Block in the blue part of the sky with a pale blue pastel, using it on its side.

4 Add the same blue to the river as well, since it will reflect the sky.

5 Use a dark indigo pastel to block in the darkest tones of the left-hand mountain, some of the foreground texture, the water's edge in places and the edge of the right-hand mountain. Block in the middle mountain with lighter pressure.

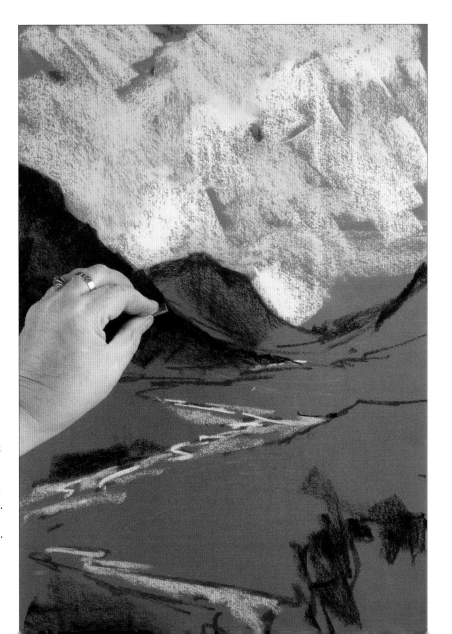

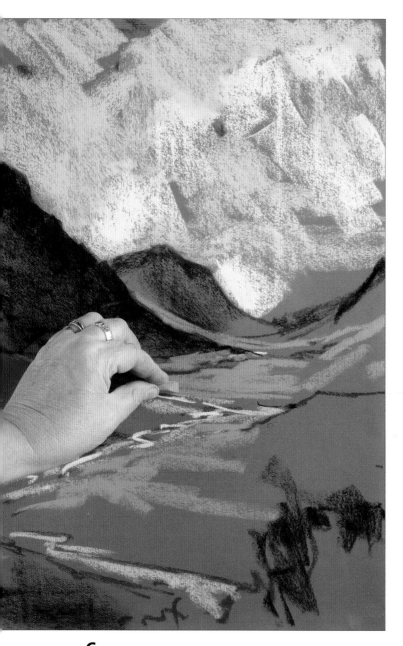

6 Paint the earth beside the water with raw sienna, a colour close to the paper colour.

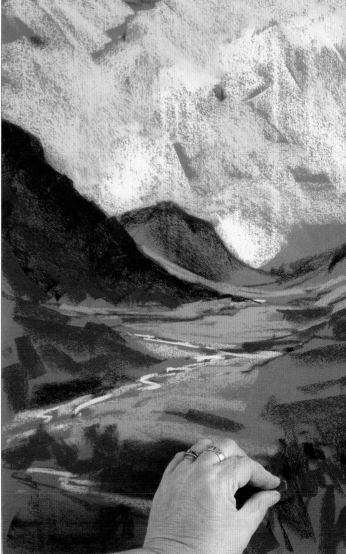

7 Use a dark brown to merge with the darkest indigo tones and to block in areas of the middle ground and foreground. Suggest texture in the foreground.

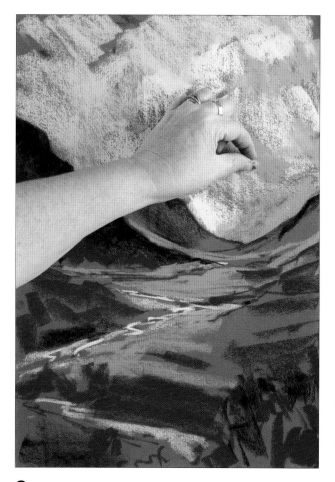

8 Add patches of neutral grey to the sky.

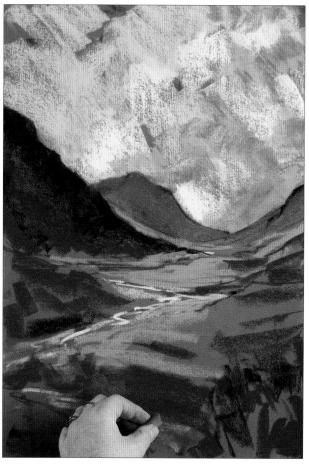

9 Block in patches of mid-blue in the clouds, mountains and river. The blocking in is now complete.

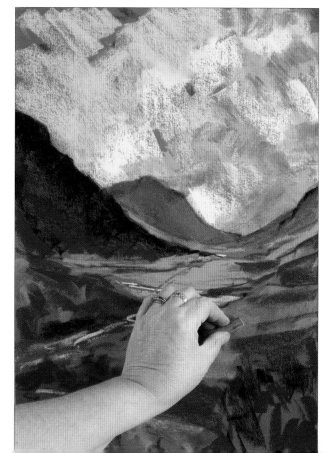

10 Take the raw sienna pastel that almost matches the paper and go over some of the parts of the painting where the paper shows through.

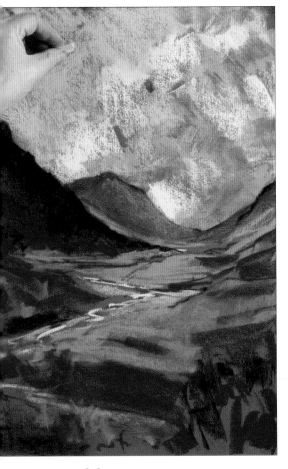

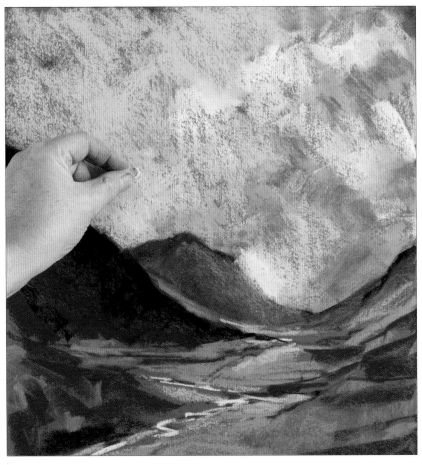

11 Add turquoise to the sky and a little on the middle mountain and in the river.

12 Warm the painting by adding a pale pink on top of some of the whites in the sky, and reflect this in the middle distance on the ground.

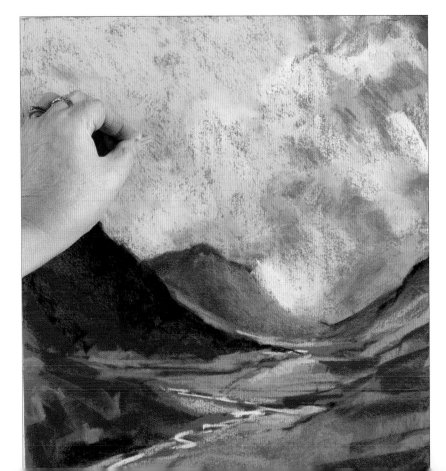

13 Take a hard pastel in pale blue and go over some of the sky. Balance the busy areas with some quieter areas by smoothing out parts of the sky. The harder pastel does not leave much residue on the paper but has the effect of blending the colours underneath.

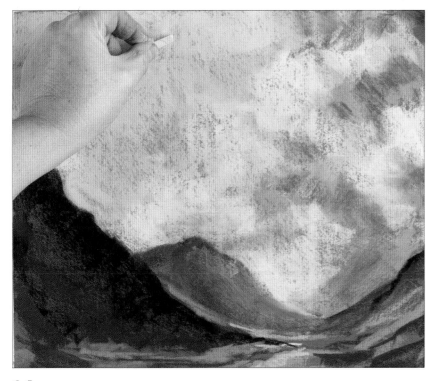

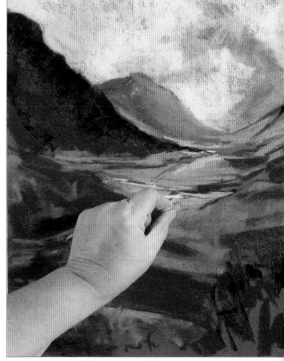

14 Go over the same quieter areas of the sky with a white hard pastel, continuing the blending process.

15 Paint neutral grey soft pastel on the hills and in the water, reflecting the sky.

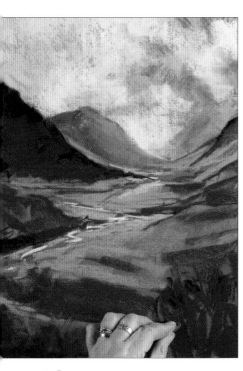

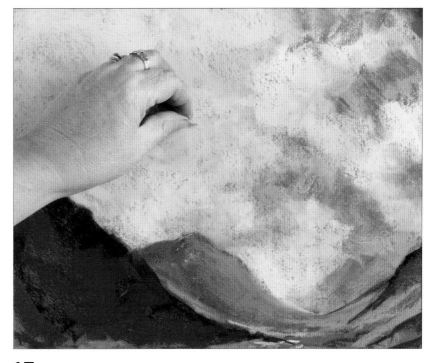

16 Apply more dark brown soft pastel to the left-hand mountain, areas of the ground on the right and the foreground. Aim to balance the dark left-hand hill with the right-hand foreground.

17 Add more pale blue to the sky with soft pastel.

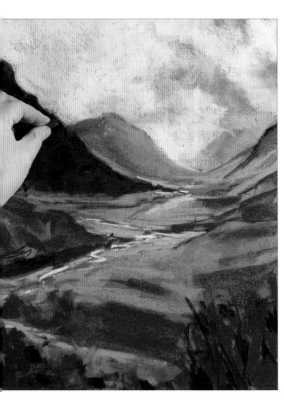

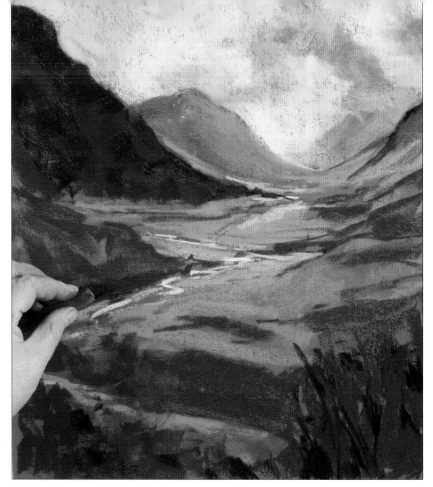

18 Add more dark indigo to the left-hand mountain and to the foreground darks.

19 Add warmth to the landscape by painting a rusty red in the foreground and the left-hand middle ground.

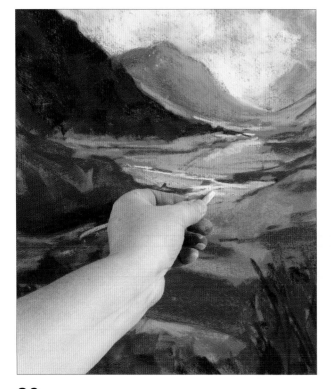

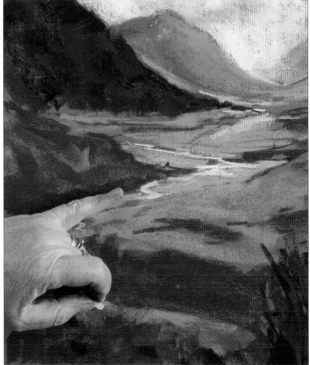

20 Tighten up the thread of the river running through the landscape using neutral grey.

21 Apply pale blue soft pastel to the river, then knock it back a little using your finger.

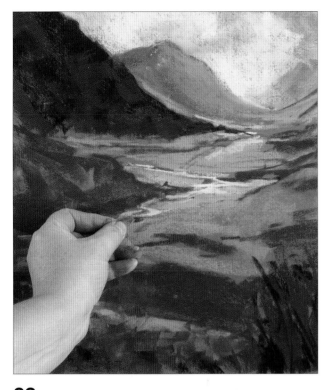

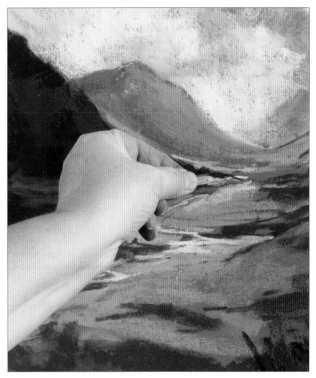

22 Continue shaping the river and add tone in the foreground water using a soft brown pastel.

23 Use the pale blue soft pastel to add highlights in the distant water.

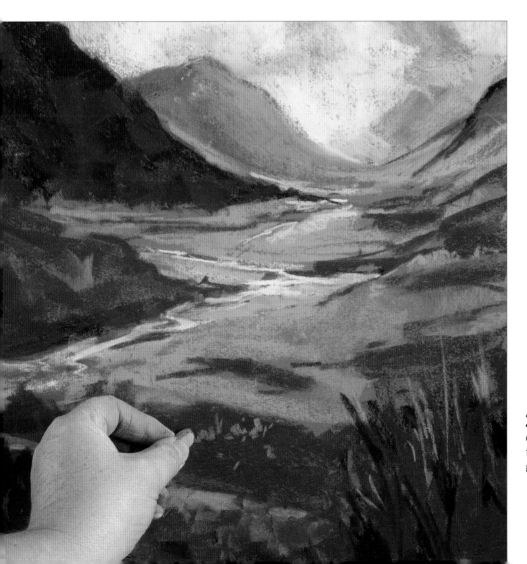

24 Make textural dots and dashes in the foreground and middle ground with yellow ochre.

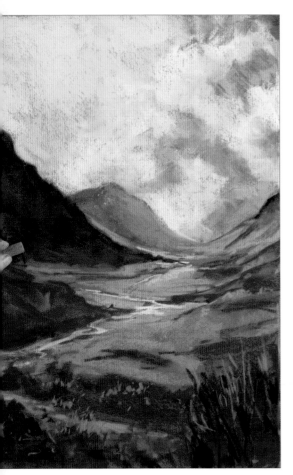

25 Glaze purple over parts of the sky, then over the darkest left-hand hill to soften it without losing its density. Continue with the purple, glazing over the middle ground, the river and the texture and detail in the foreground.

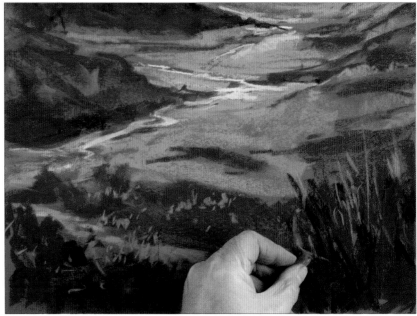

26 Use a dark brown pastel to mute down the dark indigo in the foreground.

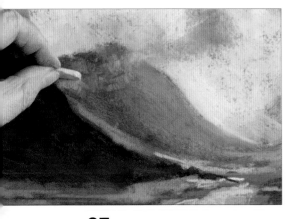

27 Take a thin piece of pale blue hard pastel and define the top edge of the middle mountain, then create mist over the face of the mountain.

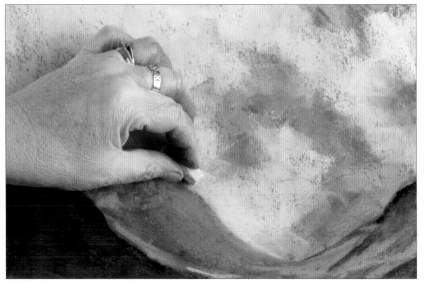

28 Knock back and soften any clouds that look too solid using white pastel.

Opposite
The finished painting.

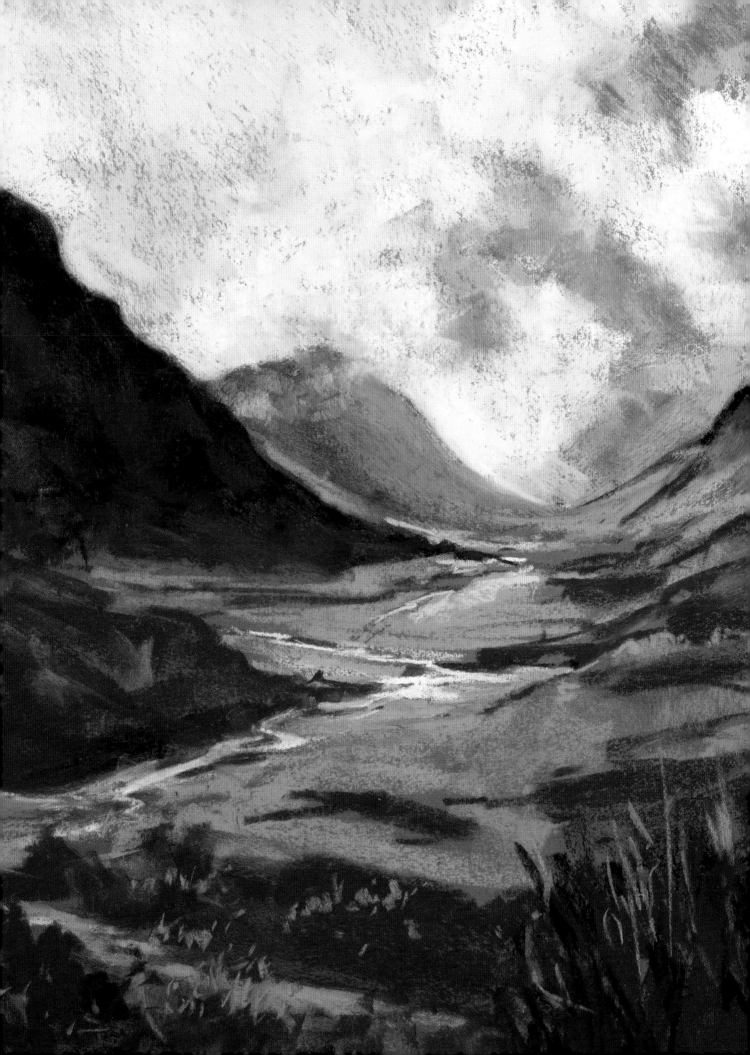

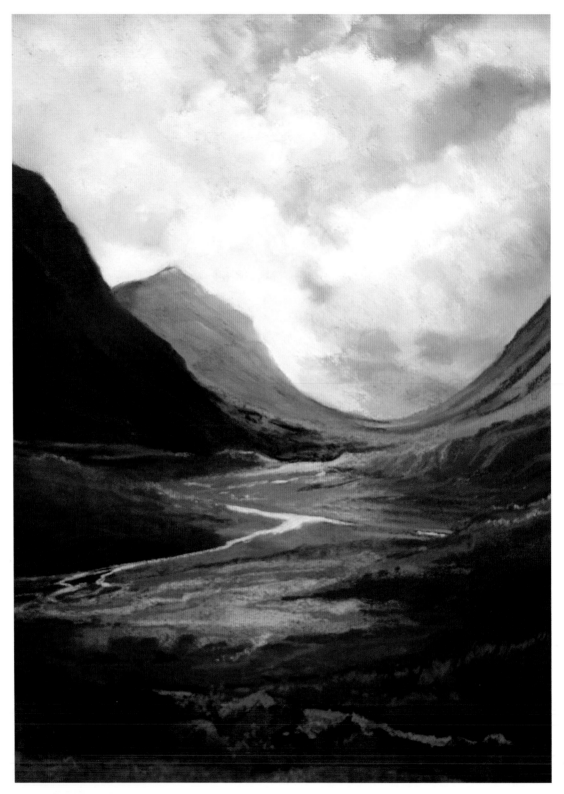

Rainclouds, Glencoe

This is the later version of the demonstration, which was finished in my studio. This raises the question I am often asked: 'What is the difference between a demonstration and a painting?' In most cases, when demonstrating, the artist should be concentrating on particular aspects of the lesson, for instance, composition, colour theory or tonal values, and the chosen subject has relevance to the lesson. However, when the lesson is finished, the painting is at a stage similar to a *plein-air* study – it either gets sold to a participant, or the artist considers whether it is a 'worthy' piece to continue with. Many of my demonstrations remain working studies, but occasionally, I will continue with them in the studio if I am happy with the results.

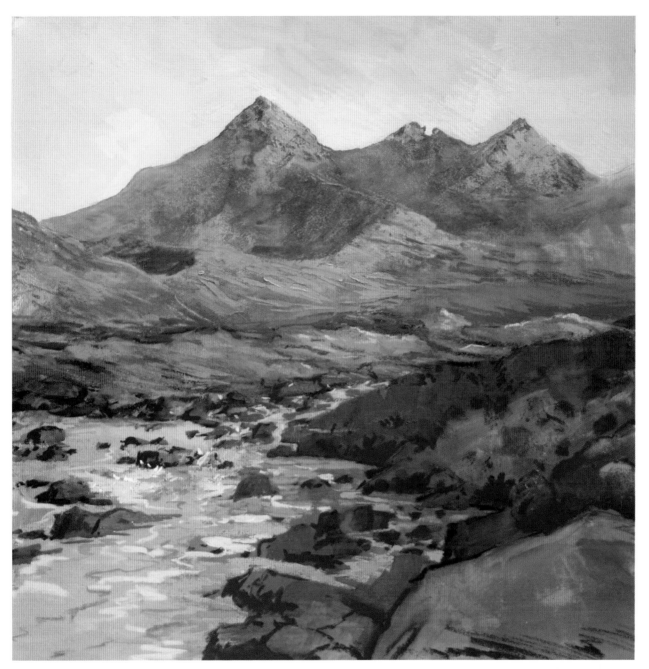

Glorious Cuillins

A similar subject, the glorious Cuillin Mountains on the Isle of Skye attract as much atmosphere and inclement weather as Glencoe, but have a different light, being so much closer to the sea. This version captures an evening light, when everything turns golden, and you would never know it had been sleeting an hour before! This studio piece was worked from quick sketches done on site, and loose, broad strokes were applied to create the feeling of immediacy captured when painting *en plein-air*.

Woods and Water

Woodland paths are always a great subject to paint as they naturally lead your eye into the trees, either into a dark void or a bright light, creating drama. Even better is finding water among the trees as the light and darks are reflected, even on an overcast day when everything else looks too flat to paint. This is a subject you can find in any country around the world, and this Australian version attracted me because of the different types and colours of tree bark. The 'looseness' of the finished piece leaves lots of shapes to the imagination, focusing mainly on the contrasts in light and shade.

You will need

Aubergine sanded paper
Soft pastels: orange, pale blue, blue-green, moss green, very dark purple, lilac, pale raw sienna, pale Naples yellow, mid-green, deep red, pale pink, neutral grey
Hard pastels: pale blue, pale pink
Gouache: light blue, white, pink, yellow
Large flat synthetic brush

The selection of pastels used in this project.

1 Sketch in the rough shapes of the foliage, trunks and rocks in the water with the tip of an orange pastel.

2 Now put in the lights of the scene to contrast with the dark paper by underpainting with gouache. Use a large flat brush and mix white with blue to block in the sky area. Mix a pale yellow for areas of the foliage and water, and a pale pink for the lower part of the sky and the water. Brush water on some of the orange pastel to create a wash. Vary the direction of the brushstrokes as shown to create dynamic shapes as you block in the lights, using negative painting around the areas of dark paper. Allow to dry.

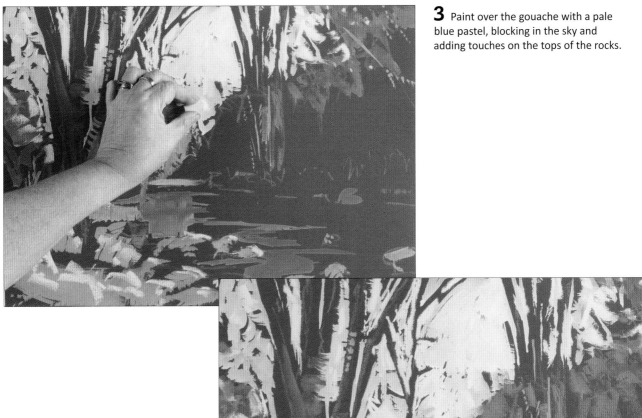

3 Paint over the gouache with a pale blue pastel, blocking in the sky and adding touches on the tops of the rocks.

4 Take a blue-green pastel and scrub in the darks of the foliage and reflections.

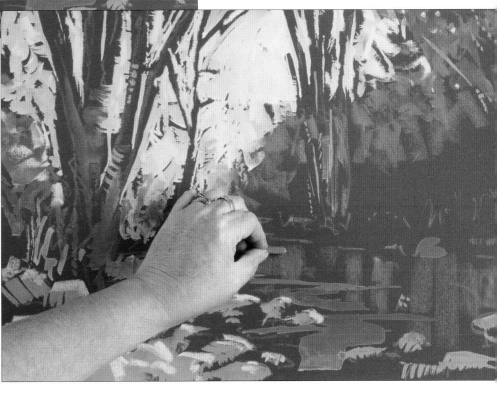

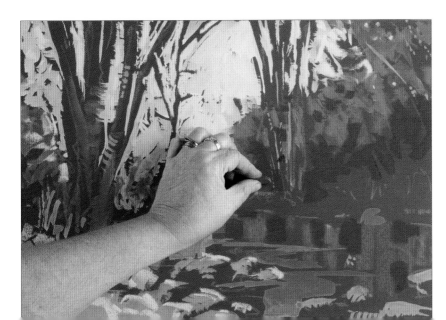

5 Add moss green pastel in the foliage and reflections.

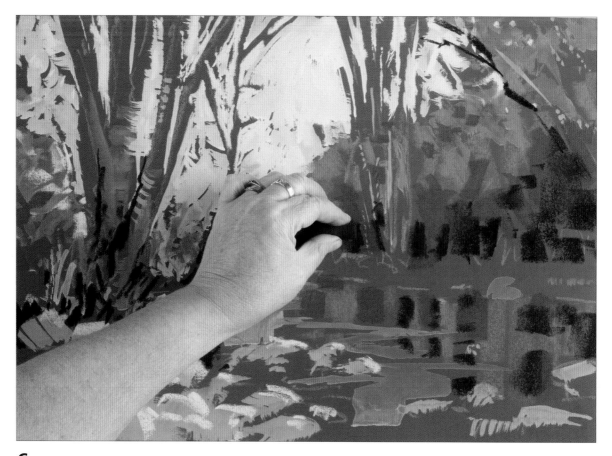

6 Use a very dark purple pastel to put in the darks on and between tree trunks and branches and in the reflections.

7 Paint some of the rocks, tree trunks and branches and their reflections with a lilac pastel. Go over some of the pink gouache background between the rocks.

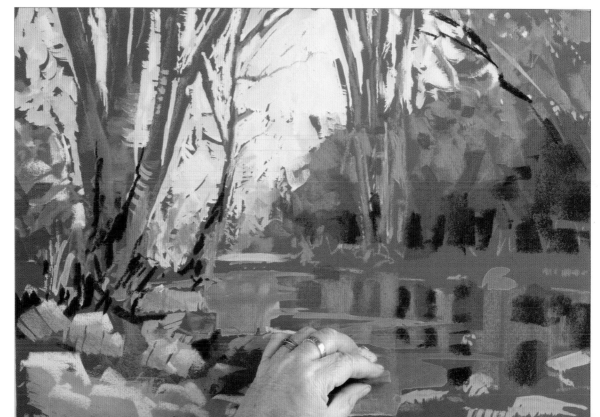

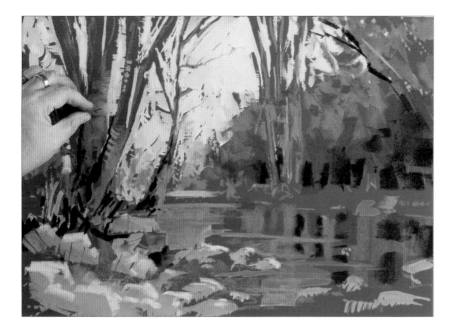

8 Use pale raw sienna to paint horizontals in the water and parts of the tree trunks.

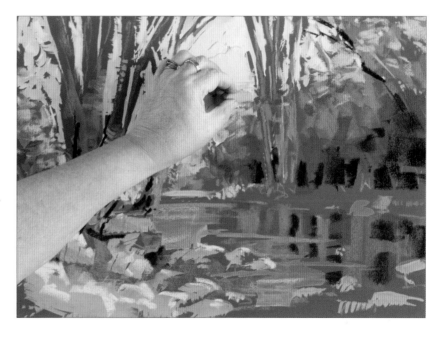

9 Use pale Naples yellow to create highlights in the foliage and add some grasses in the middle distance. Add some horizontals in the water in the same way.

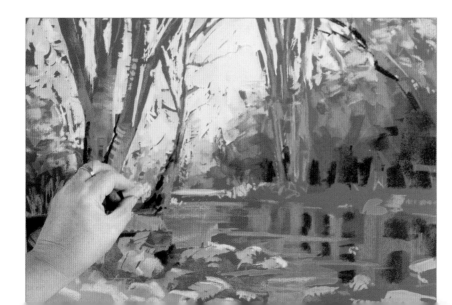

10 At this point I felt that some of the trunks and branches needed thinning down, so I used the pale blue of the sky to achieve this through negative painting.

85

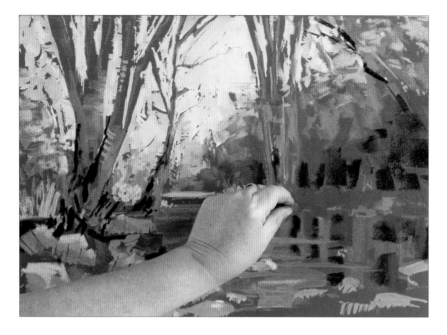

11 Use the moss green pastel to paint foliage on the right-hand bank, and its reflection.

12 Paint mid-green touches in the right-hand foliage and in the grasses under the trees, to capture the effect of woodland half-light.

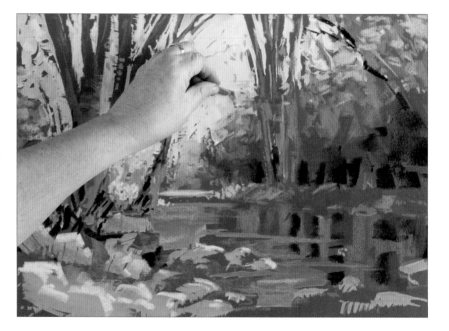

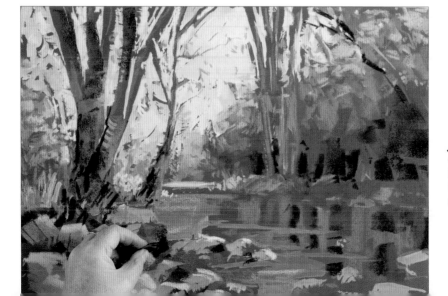

13 Use a deep red pastel to paint patches in the distant trunks and foliage, the main tree on the left and among the rocks.

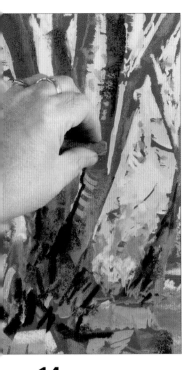

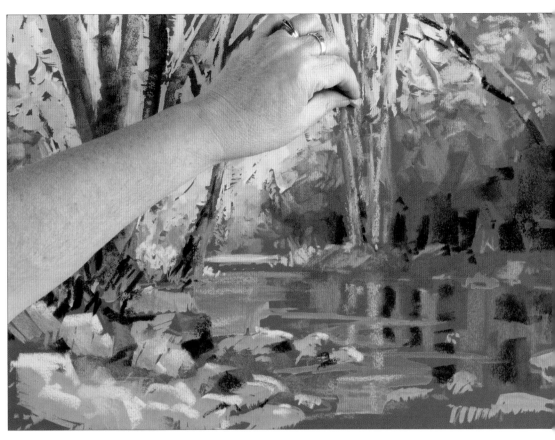

14 Glaze orange pastel over the deep red on the left-hand tree to knock it back a little.

15 Use pale pink to lighten some of the trunks and branches, fading them into the sky a little. Add touches to the reflection and the foreground rocks.

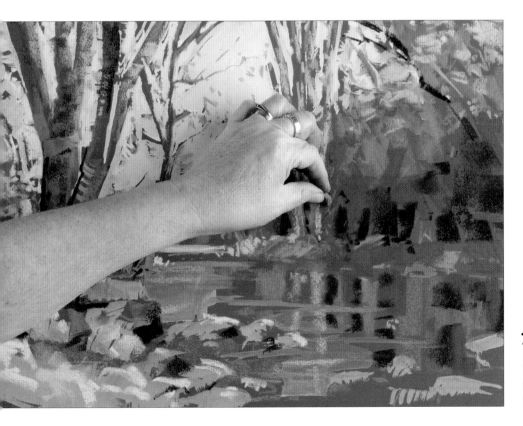

16 Apply more moss green in the foliage on the right-hand side, using this colour to reshape the tree trunks with negative painting.

87

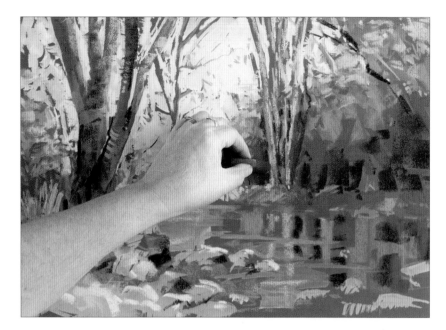

17 Reshape the main tree on the right using very dark purple, painting negatively.

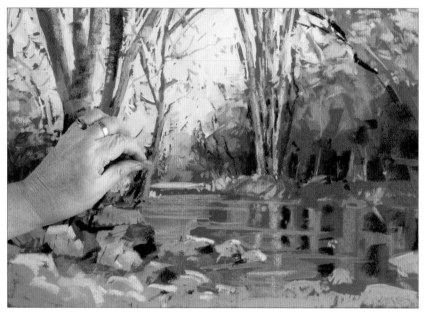

18 Use a neutral grey to knock back any exaggerated colour such as the horizontal lines in the water, some of the foreground rocks and areas of the tree trunks. Add trunks on the right.

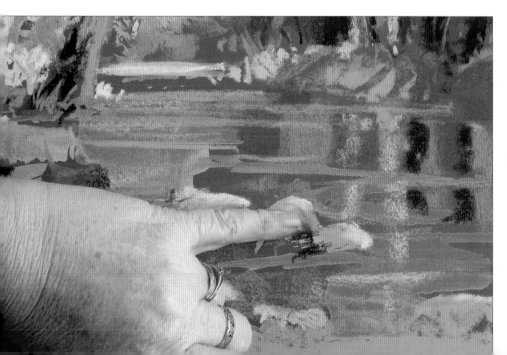

19 Take a pale blue hard pastel and use it to blend and fuse the cool highlights on the rocks. Push in and soften the pastel with your finger.

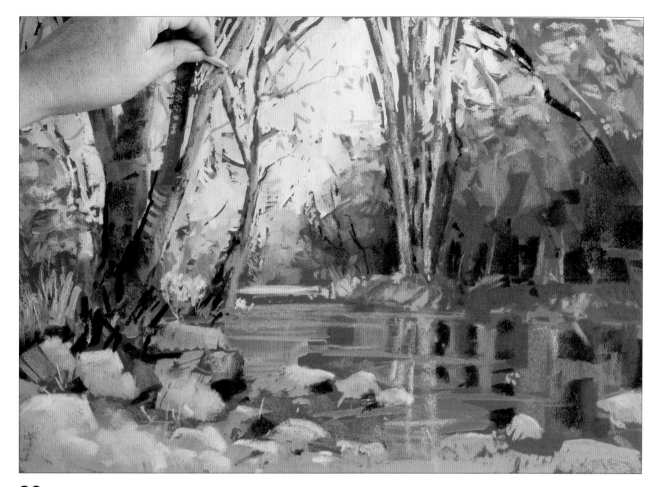

20 Use a pale pink hard pastel on the highlighted parts of the rocks in the same way to blend and soften, creating calmer spaces to balance the animation elsewhere. Continue with this technique on the trunks and branches and their reflections. Add grasses in the foreground with the same pale pink. Step back from the painting at this stage to see what, if anything, remains to be done.

21 Make any final adjustments to your painting. I knocked back some of the yellow in the foliage using moss green soft pastel.

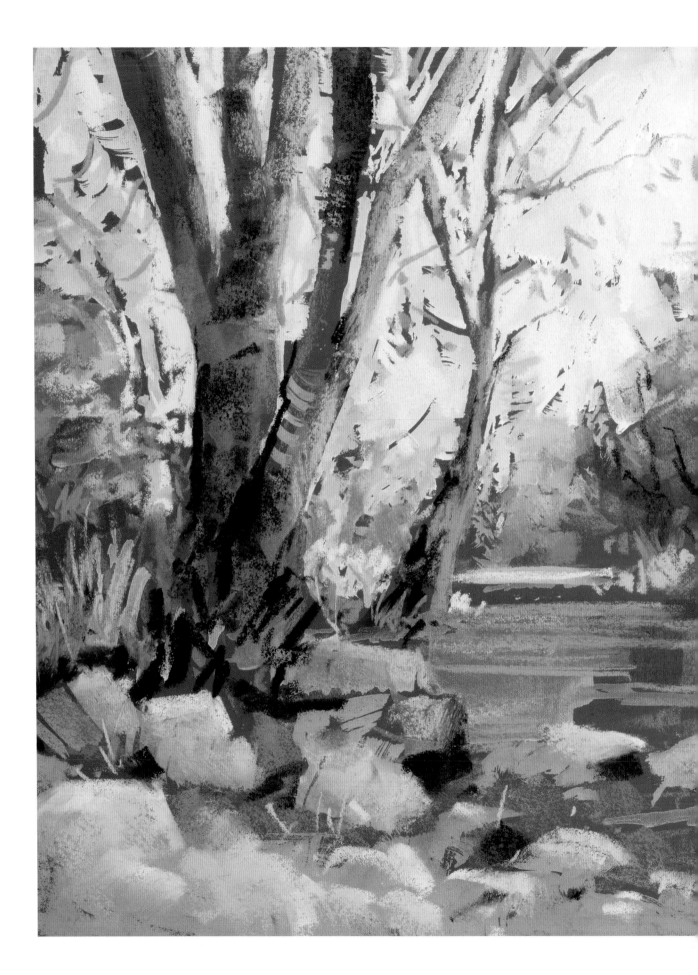

The finished painting.

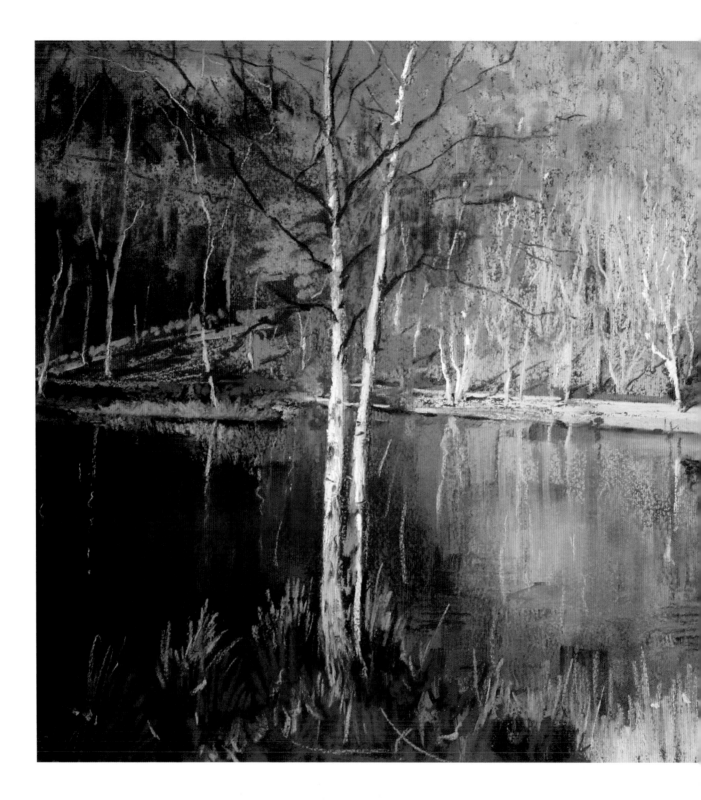

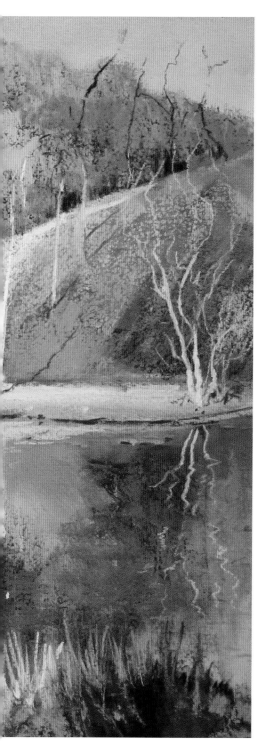

Autumn Golds

In a similar scene, looking across a loch in the Trossachs, Scotland, the loose abstracted shapes applied with layers of pastels suggest layers of trees in the background, also reflected in the water. These allow the strong, light shapes of the silver birch trees to shimmer in the autumn sunlight.

Tuscan Hillside

My frequent visits to Tuscany always inspire me, as the soft light in the valleys among the Appenines creates dreamy, misty scenes, with hilltop villages scattered all around. The mood incites me to use a softer-toned paper, rather than the strong or bright colours evoked in other subjects, and the light earthy tones of sandpaper help to catch the colours in the land.

You will need

Art sandpaper
Soft pastels: pale sky blue, pale blue, turquoise, pale lime green, sage green, dusty blue, flesh tint, mid-lime green, pale blue-green, dark green, cream, white, very dark forest green, deep blue, pink, purple-grey, pale purple-grey, terracotta, pale green, burnt orange, mid-blue
Large flat synthetic brush
Kitchen paper

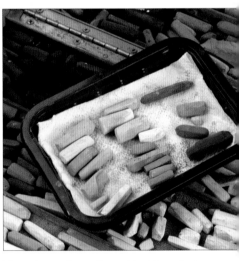

The palette of pastels used in this project.

1 Block in the main areas with pale sky blue and pale blue for the sky, then add touches of turquoise in the sky and on the foreground hillside on the left and right. Use a pale lime green for the middle ground and then a sage green for the distant hills and the edge of the foreground hillside. Paint a dusty blue diagonally from the right-hand distance, across the middle ground and on the left-hand side of the near hillside, then glaze pale blue on top of this. Paint the rough shapes of the buildings with flesh tint, and use the same pastel to paint the track going diagonally across the middle ground. Block in the nearest foreground with mid-lime green. Add touches to the lower sky and distance with pale blue-green.

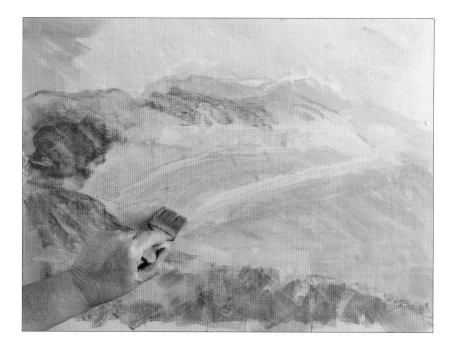

2 Wet a large flat synthetic brush, blot it on kitchen paper and brush over the pastel underpainting. Change the direction of the brush to suggest the features of the landscape. Some pastel colours go temporarily dark when wet, so don't worry if you do not initially like the effect.

3 While the underpainting is wet, work into the buildings with the flesh tint pastel to define the shapes. Add the same colour to the track.

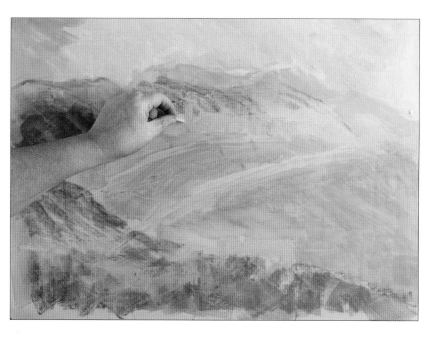

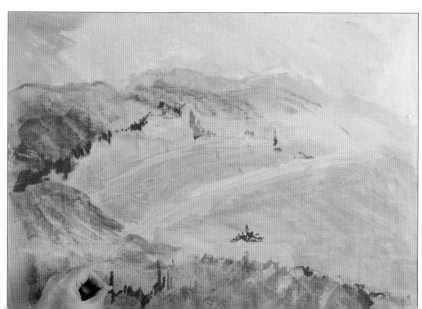

4 Use the tip of a dark green pastel to suggest cypress trees and dark areas of greenery in the landscape. Work into this with a sage green pastel.

95

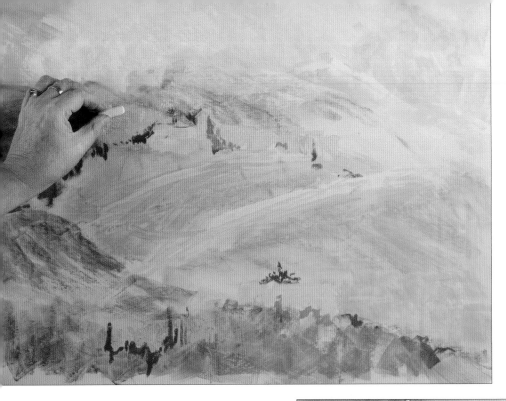

5 Build up the pastel on the sky and the distant hills with pale blue-green. This will create an interesting uneven texture if some of the underpainting is dry and some still wet.

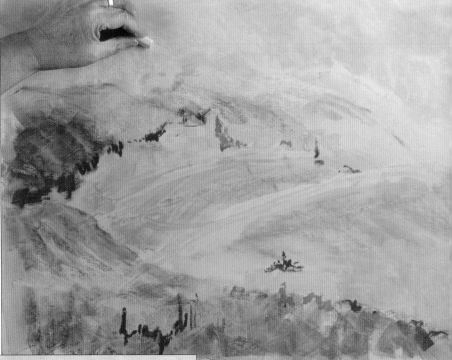

6 Use pale sky blue in the sky and distance, and to create irregular texture on the foreground hillside.

7 Apply cream pastel to the buildings and over some of the grass to marry the earth tones of the painting.

8 Paint the highlighted walls of the buildings with white pastel.

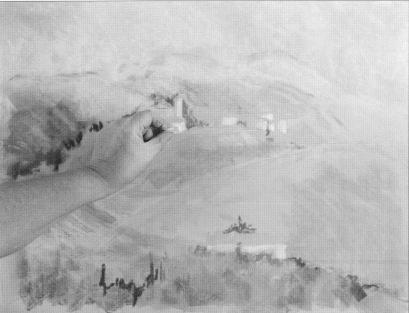

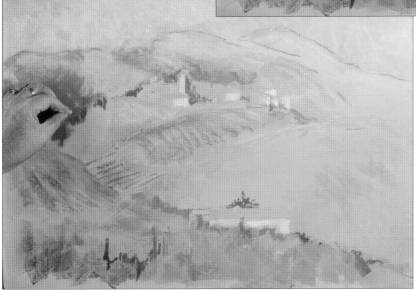

9 Use the tip of the sage green pastel to add linear detail in the hills and around the buildings, and to suggest vineyards. Use the side of the same pastel to build up the dark area of texture on the left.

10 Build up the cypress trees and the greenery around the buildings with a very dark forest green.

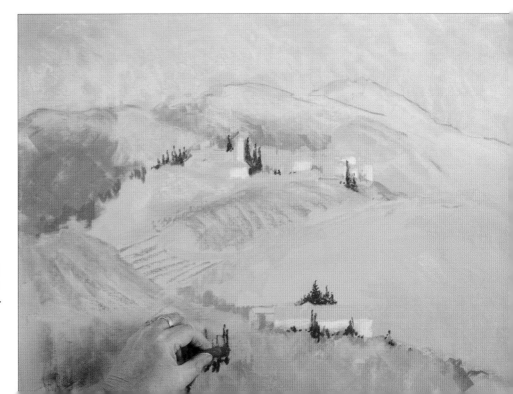

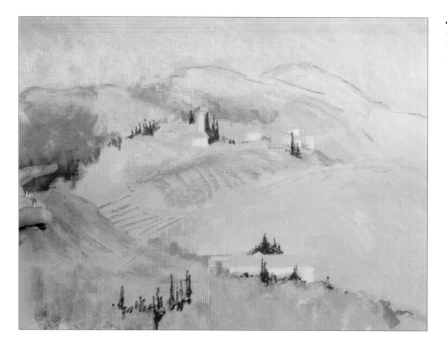

11 Paint deep blue on the far left of the scene and rub it in with your finger to blend and knock it back.

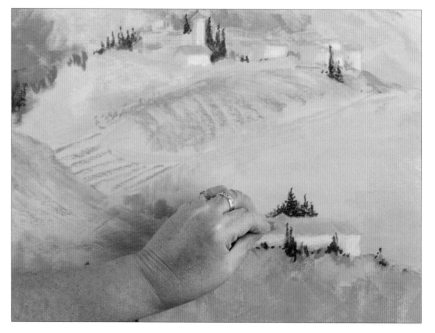

12 Use pink pastel for the pantiles on the roofs; it should be a deeper colour than the flesh-tint.

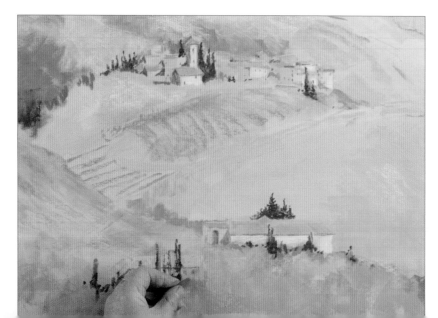

13 Paint the walls of the foreground building in the same pink. Use a purple-grey down the shadowed sides of the buildings, using the tip for the lines under the eaves and for the windows.

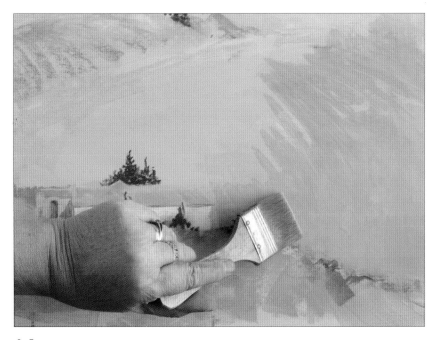

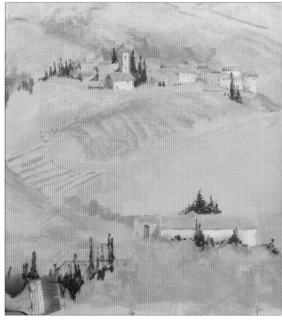

14 Re-wet some areas of the painting with the large flat brush, used just damp. Solidify some of the colours and create directional strokes to indicate the landscape.

15 Pick up some of the cypress colour with the damp brush and work on the tree shapes in this way.

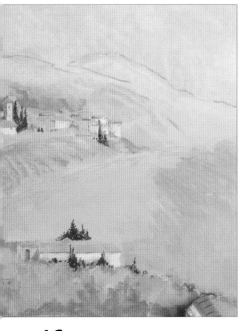

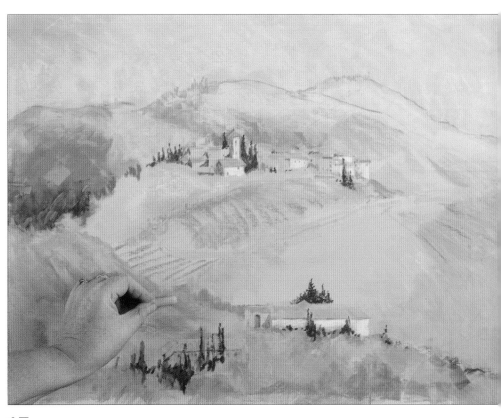

16 Clean the brush again and use it damp to add texture and strength at the bottom of the painting.

17 Use a pale purple-grey soft pastel to add neutrals to the hills on the right, going over the dry background. Add loose touches to the foliage on the left and in the middle ground.

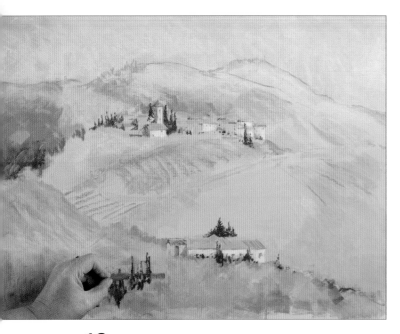

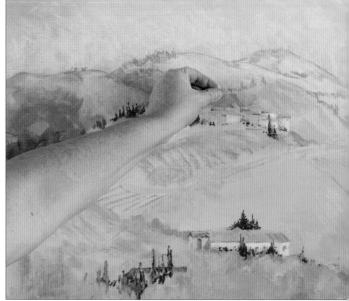

18 Use a terracotta pastel to paint the wall of the foreground building where it shows between the cypresses. Add a little of the same colour on the roof tiles and windows of the right-hand buildings and in the village in the distance.

19 Add sage green pastel in the distant hills to create texture and break up the colour. Suggest distant trees.

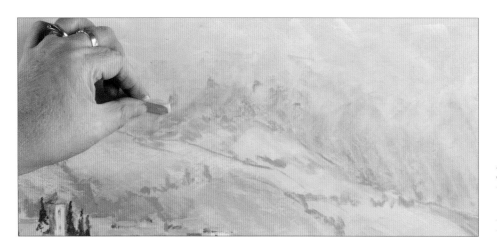

20 Glaze over the distance with a deep blue pastel to help the hills stand out, then apply pale blue to suggest the further distance.

21 Add texture with pale green on the left-hand side, suggesting the cool green of olive trees, then add dots and dashes in the foreground.

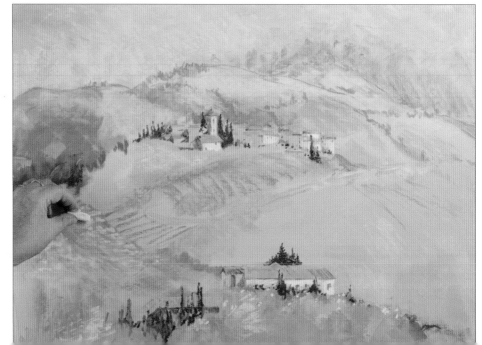

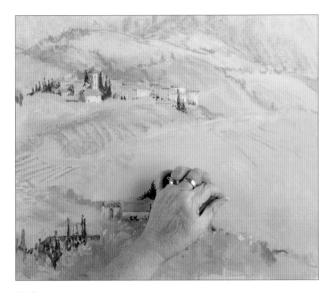

22 Paint pale lime green over the right-hand fields and in front of the foreground house, with a dotting and scribbling motion to create texture.

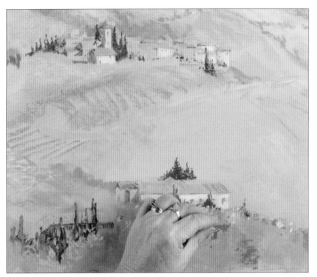

23 Use a burnt orange pastel to create texture and warmth in the foreground.

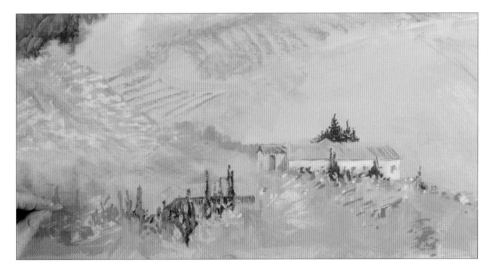

24 Add trees in the foreground with the tip of the sage green pastel.

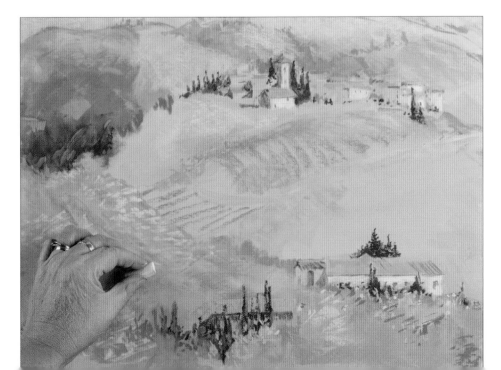

25 Add texture and detail to the left-hand side of the painting using a mid-blue pastel.

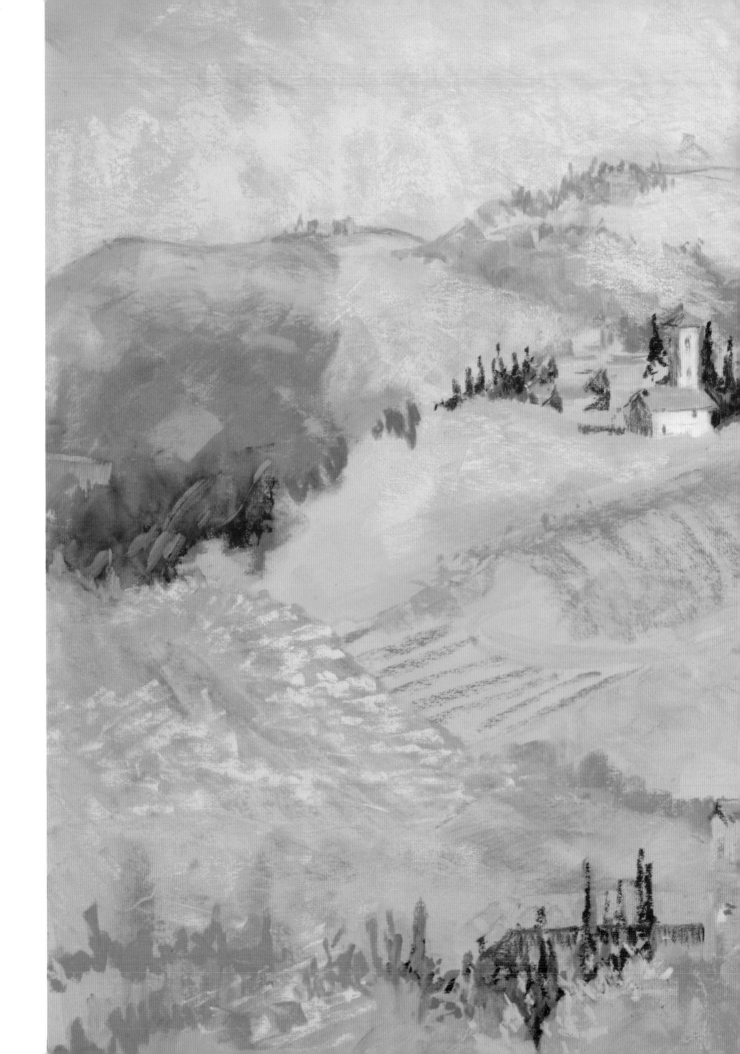

The finished painting.

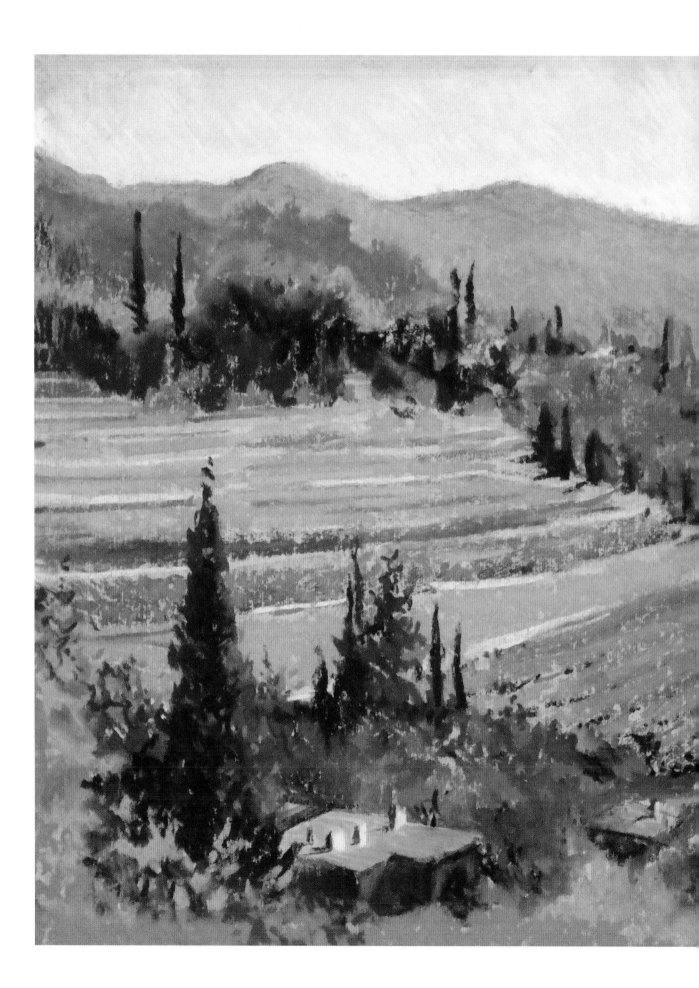

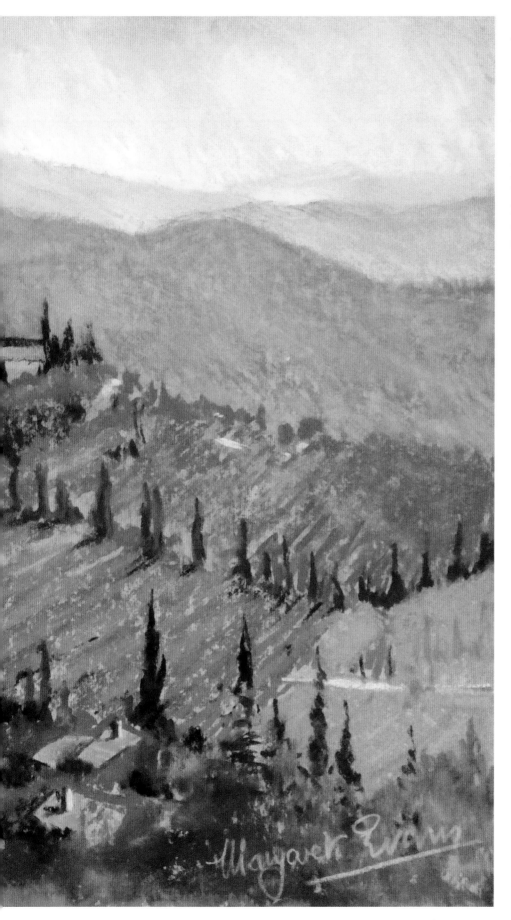

Provence Landscape

The same sandpaper colour has been used for this scene of a hillside near Provence, France, painted *en plein-air* as a demonstration to a group. Knowing I didn't have much time to capture the scene (the bus was leaving with or without us in thirty minutes), I used the sandpaper colour as a shortcut and built up the layers of terraces with soft blue-greens, strengthening into soft greens, then dark greens, to accentuate the pink roofs of the houses scattered along the hillside.

Evening in Venice

Different settings evoke different reactions in me, and when I'm in Venice, I love the strong, hard shapes of the buildings and the dynamic contrasts they make against the skies. Day time skies are usually pale turquoise and pink, but late afternoon or evening skies become stronger, and this is when I'm inspired to throw on some colour boldly, wet it and let it run, then work my subject into the wash as a vibrant contrast.

You will need

White sanded paper

Soft pastels: pale orange, deep orange, red, purple, very dark purple, dark teal, turquoise, very pale turquoise, very pale pink, pale cream, very pale peachy pink, cobalt blue, white, teal, peachy pink, pale blue

Hard pastel: dark purple

Large flat synthetic brush, 2.5cm (1in) flat synthetic brush

The palette of pastels used in this project.

1 Begin preparing the background by applying pale orange and deep orange pastel.

2 On the left and right of the painting area, add red pastel.

106

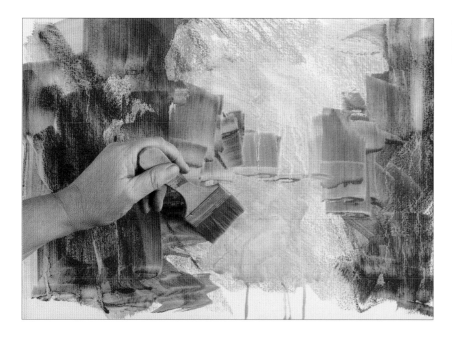

3 Wet a large, flat synthetic brush and brush over the dry pastel background to suggest shapes as shown.

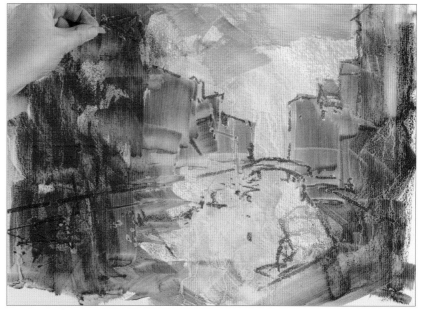

4 Take a purple pastel and use the tip to sketch in the shapes of the scene on the wet background.

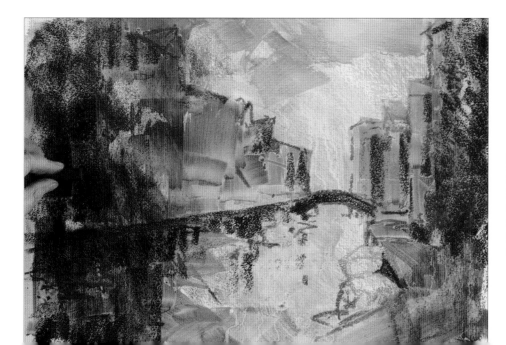

5 While the background is still wet, block in the darkest tones of the painting with very dark purple pastel to create the shadowed parts of the buildings and their reflections in the canal.

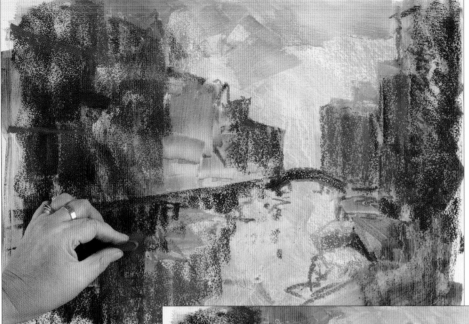

6 Add blocks and lines of dark teal to the buildings and their reflections.

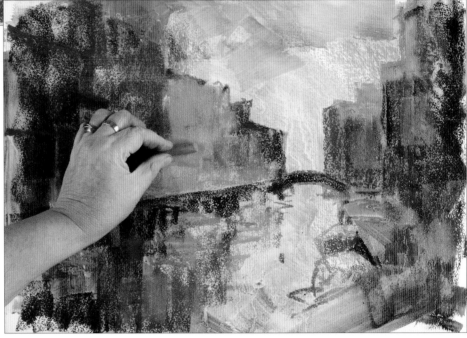

7 Block in brighter areas of the buildings and reflections with turquoise.

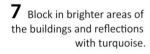

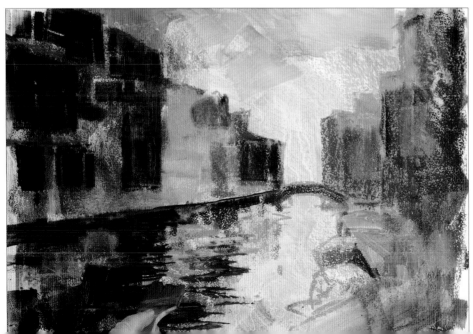

8 Take the large flat brush, wet it and pull down colour in the very darkest areas of the buildings and reflection. Paint horizontal strokes, wiggling them forwards, for rippled reflections.

9 Use the wet brush while it still has the dark purple on it to block in the shapes on the people on the right-hand side of the painting.

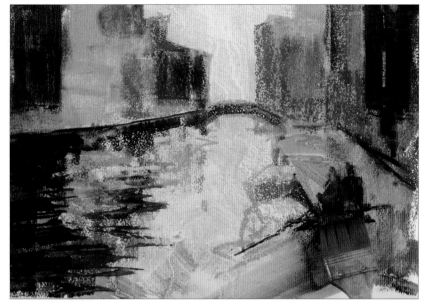

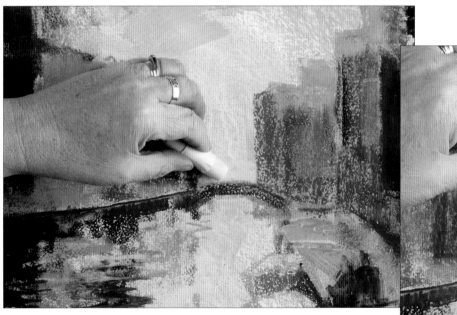

10 Paint very pale turquoise in the far distance, beyond the bridge. In the lower sky behind this, paint with very pale pink on top of the orange, then pale cream on top of this. Continue with the pale cream in the water, reflecting the pale part of the sky.

11 Continue with the pale cream pastel. Block in the area around the figures to make them stand out, then add dashes of highlight to the buildings.

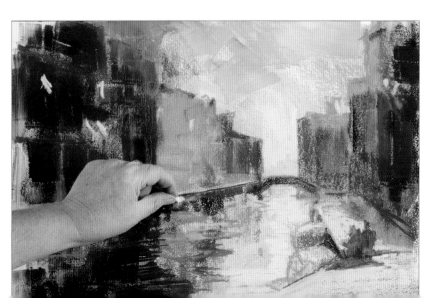

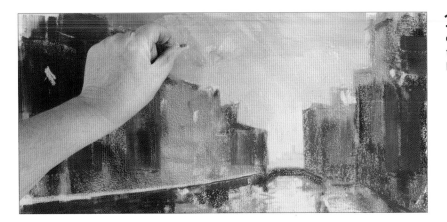

12 Use a very pale peachy pink over the orange in the sky, scumbling to reduce the raggedness of the brush marks.

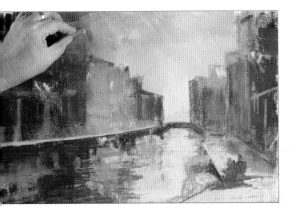

13 Paint more turquoise on the buildings and in their reflections in the water.

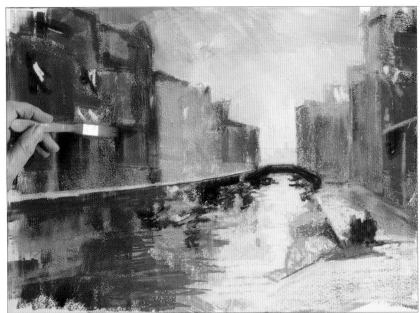

14 Take a 2.5cm (1in) flat brush and wet it, then use it to darken and solidify the darker tones of the buildings, bridge and reflections.

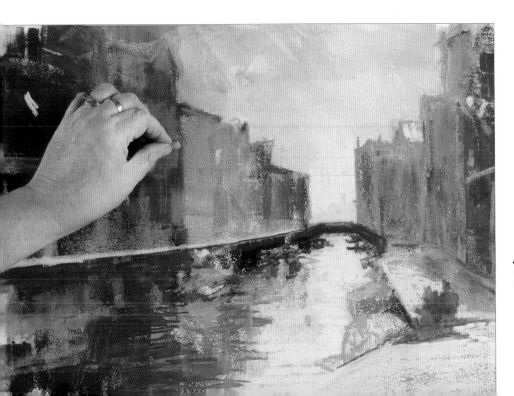

15 Use cobalt blue to suggest architectural details on the buildings on both sides of the canal.

16 Use a large white pastel to highlight the edge and the lightest parts of the quayside on the right.

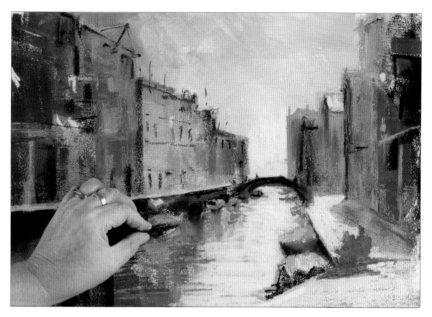

17 Use a dark purple hard pastel to structure the shape of the bridge and the building details, plus some of the darker parts of the boats in the water. Soften some of the pastel with your finger and drag it down for the reflections.

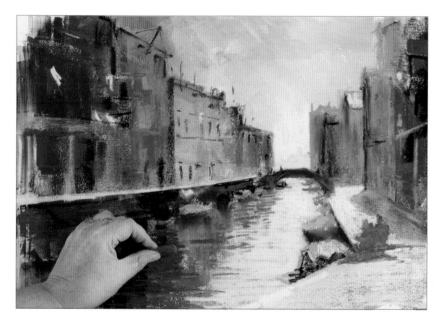

18 Add dark tones in the water with dark teal and soften them in with your finger to create ripples.

19 Use turquoise again, adding a touch to the left-hand figure and to the ripples in the water. Use the tip to create dots and dashes.

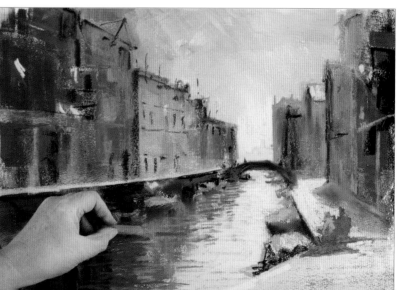

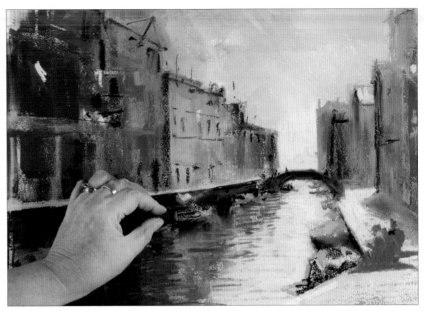

20 Darken and define the figures with the teal pastel.

21 Use red to add bright touches to the boats and buildings.

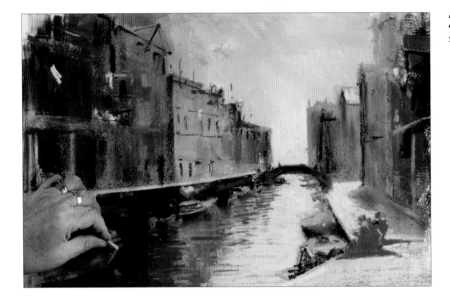

22 Knock back the red with a few strokes of peachy pink.

23 Create a warm, Venetian glow in some of the cooler areas with the orange used in the initial wash.

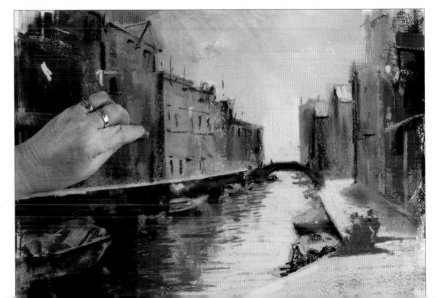

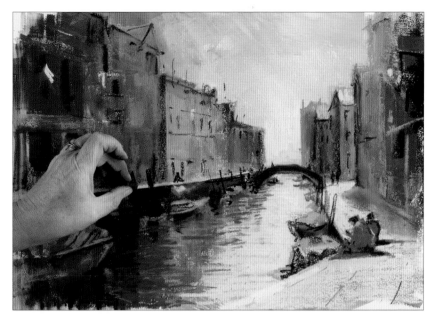

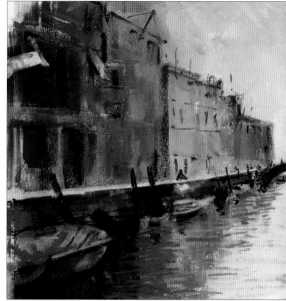

24 Use the dark purple hard pastel to tighten up and add details. Work on the shape of the bridge, add figures and clarify the figures in the foreground. Add structure and windows to the buildings and poles for tying boats. Suggest the form of the boat on the left and its reflection, and make perspective marks in the quay on the right. Use your finger to soften in the details where needed.

25 Refine the form of the foreground boat on the left with dark teal, going over some of the red to avoid this catching the eye too much. Paint the shutters of the building on the far left with pale blue.

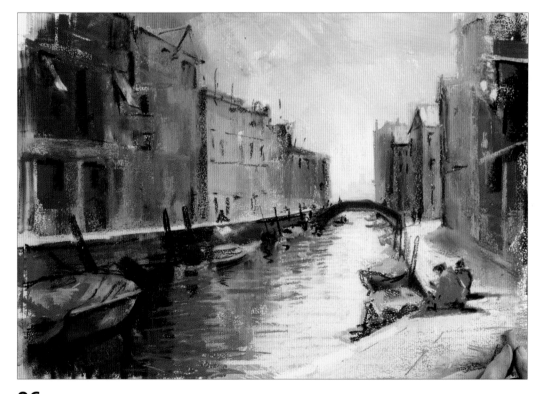

26 Paint red at the far right and bottom of the painting, then a little orange to balance the scene.

Overleaf
The finished painting.

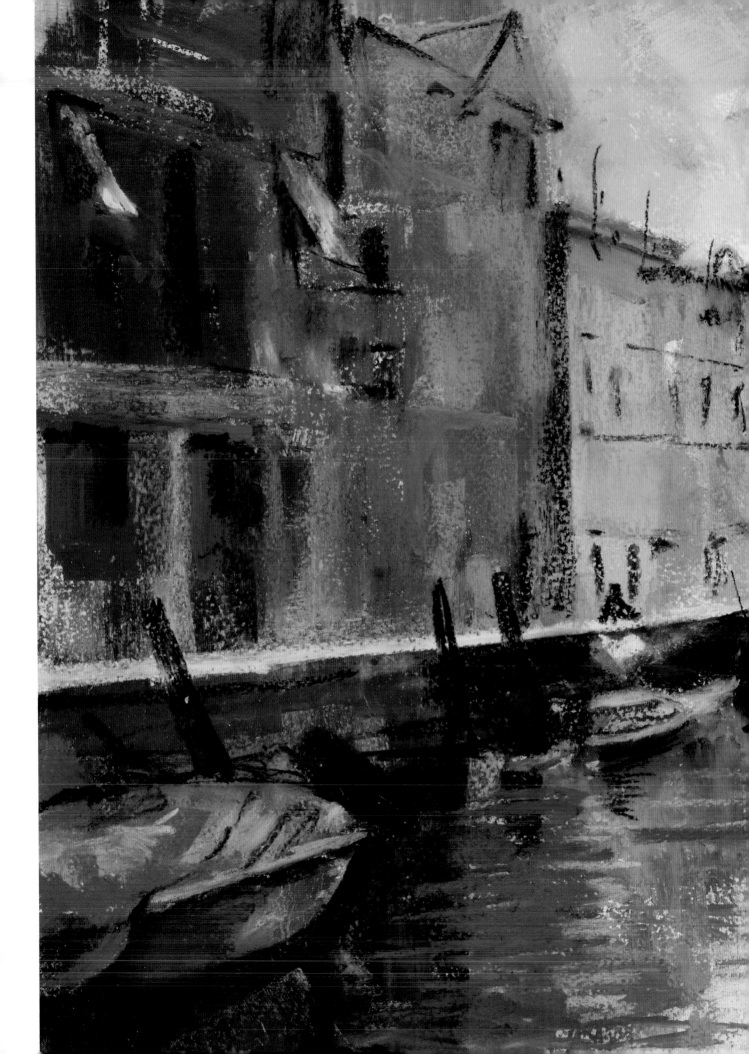

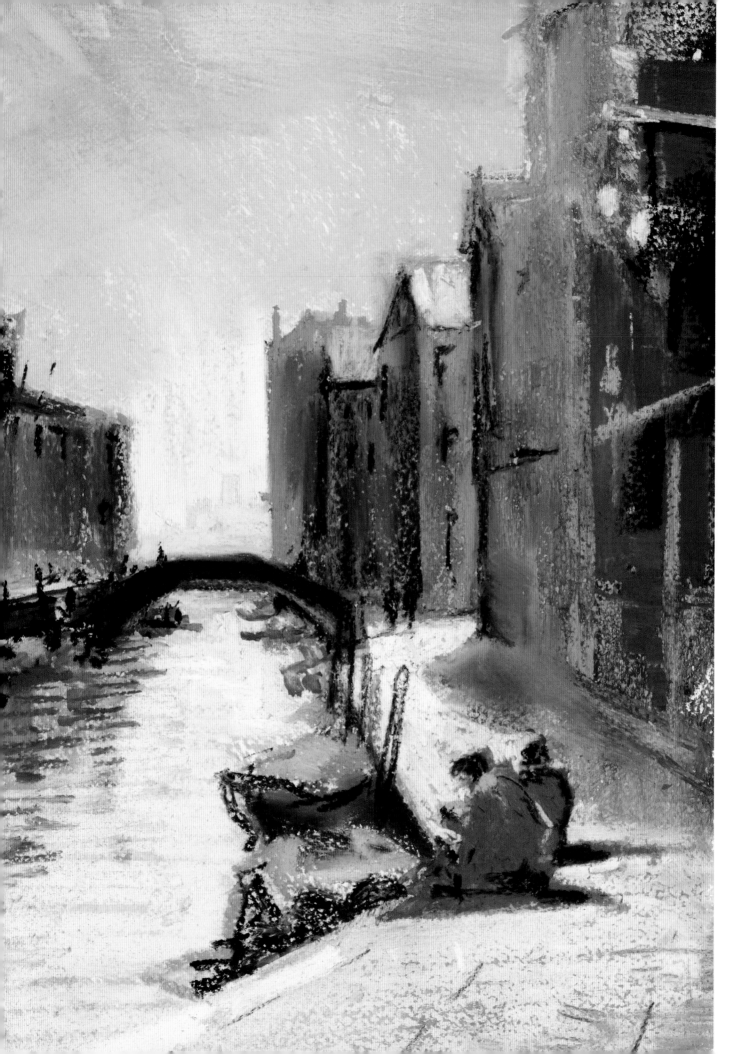

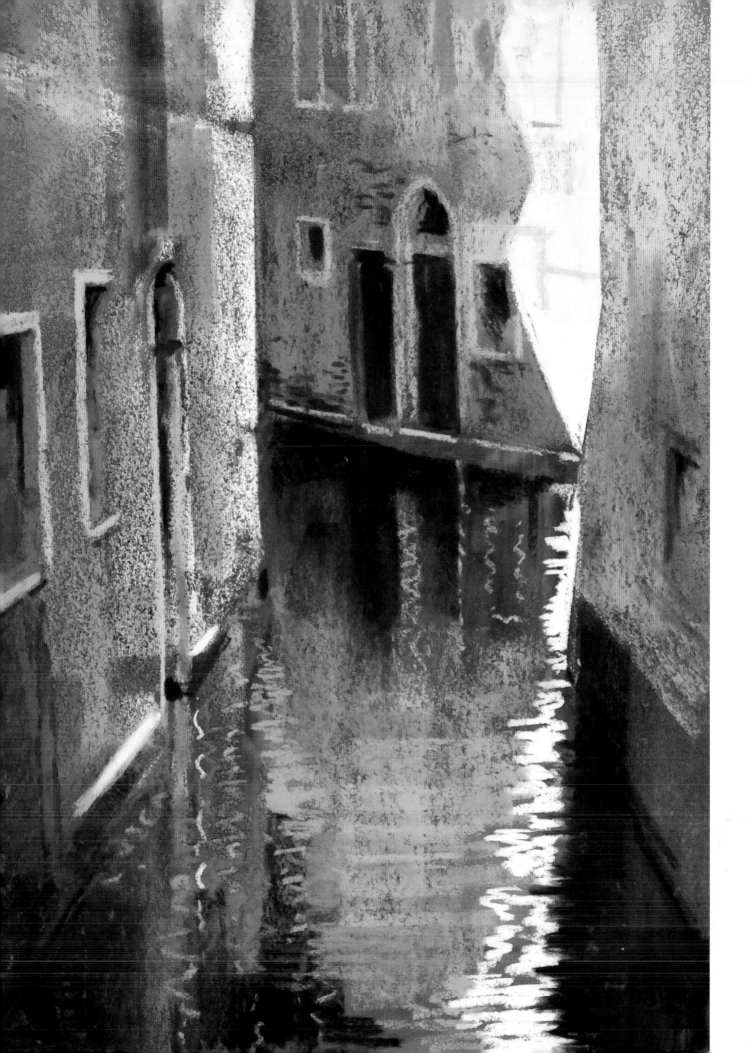

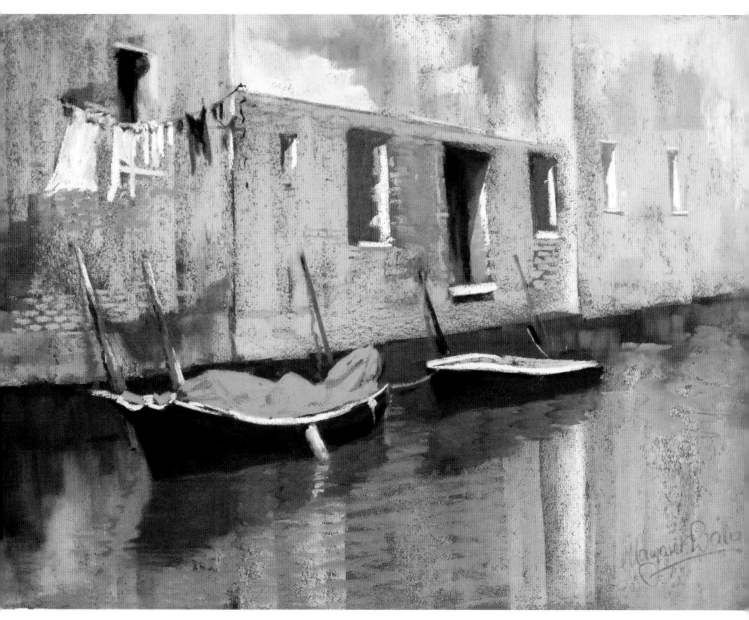

Pink Glow, Venice

Here a shocking magenta-pink underpainting was inspired by warm lights, and then the soft, cool greenish tones of the water and the pale, creamy colours of the crumbly buildings were built up with light, transparent layers to quieten the underlying base colour. It is great to unleash bold, vibrant colour at the start of a painting. With pastels, it can always be quietened down later, but initially it gives a random sense of excitement to a painting, and the artist's own character will determine how much of it remains at the end!

Opposite

Turquoise Reflections, Venice

Between the milky green-blues of the lagoon colours, and the still, almost stagnant tones of the canals, I had an overwhelming urge to use a strong turquoise base of phthalo turquoise to cover a white sanded paper. This gave me a vibrant background as I developed the building colours with hot terracottas, lilac mid-tones and indigo shadows. These strong, dark combinations unite to contrast the bright shaft of sunlight from the corner of the building.

Coastal Scene

The Isle of Arran offers the artist a huge variety of inspiring subjects, as the entire island is like a miniature Scotland, and therefore the coast varies from north to south and from east to west. I love the tranquil west coast, not only for its quality of light, but also for these fishermen's cottages known as the Twelve Apostles.

You will need

Pastel card with a compressed cork surface for use with dry media

Soft pastels: very pale peach, pale cerulean blue, very pale blue, pink, cream, ultramarine, deep cool green, warm green, lilac, ochre, dark indigo, grey, pale blue, purple-grey, golden brown, bright yellow

Hard pastels: brown, forest green, pale blue

French grey pastel pencil

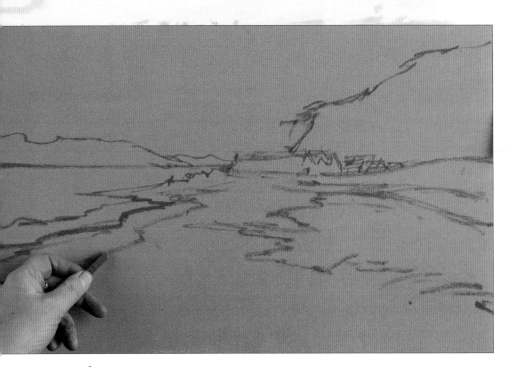

1 Sketch in the scene with the tip of a brown hard pastel.

The palette of pastels used in this project.

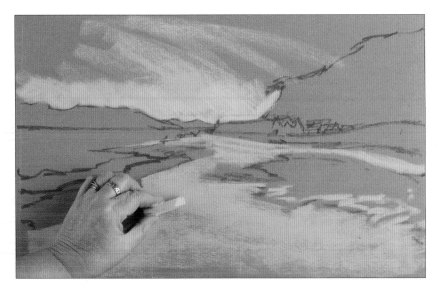

2 Use a very pale peach soft pastel to create warm light in the sky, and for the sand on the beach.

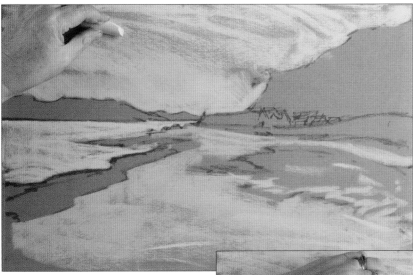

3 Paint the upper part of the sky with pale cerulean blue, and use the same colour to establish where the sea is and to add touches to the beach.

4 Use a very pale blue to sweep over the sky and to highlight the lightest tones in the painting.

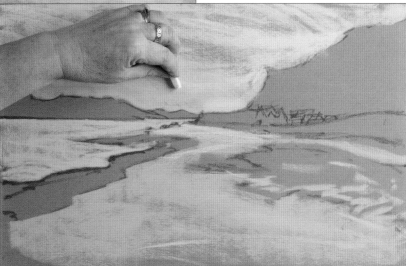

5 Use pink to paint the headland on the left and the hill on the right.

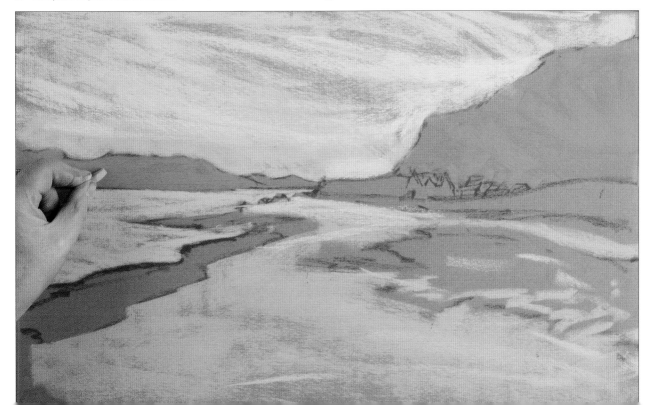

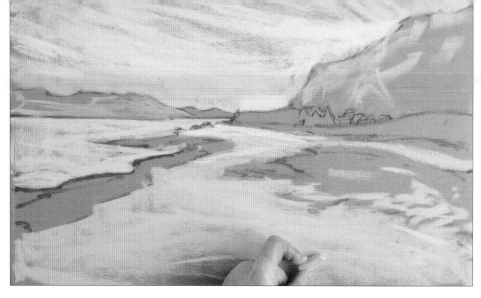

6 Paint cream loosely over the pink and the beach.

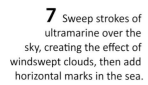

7 Sweep strokes of ultramarine over the sky, creating the effect of windswept clouds, then add horizontal marks in the sea.

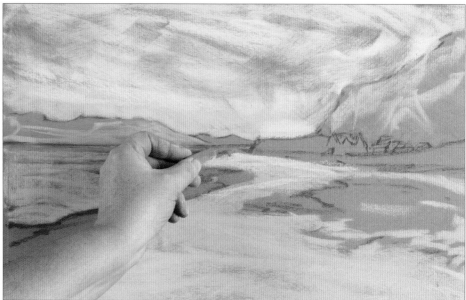

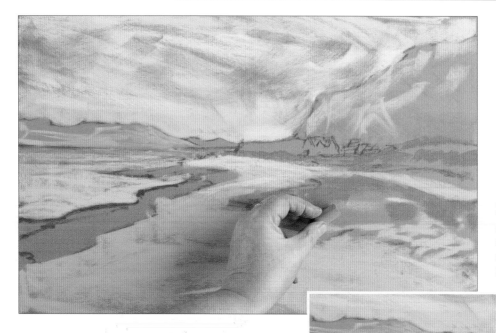

8 Paint patches of deep cool green for foliage on the beach area, then change to warm green and paint this over parts of the beach.

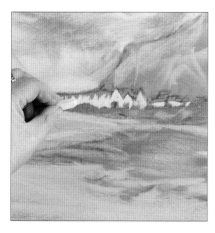

9 Use the tip of a very pale blue pastel to block in the buildings.

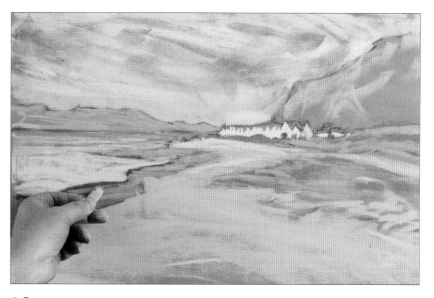

10 Use lilac in the foliage area of the beach and on the distant headland, applying it with sweeping strokes.

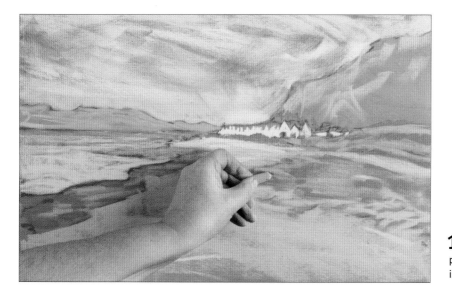

11 Apply ochre pastel wherever the paper is still showing through, since this is close to the colour of the paper.

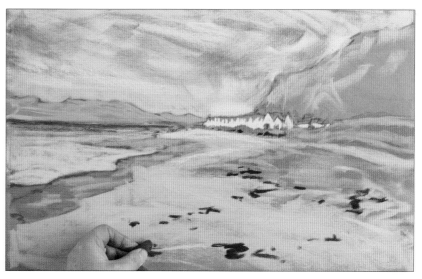

12 Use dark indigo to create dots and squiggles suggesting shadows under foliage and debris on the beach.

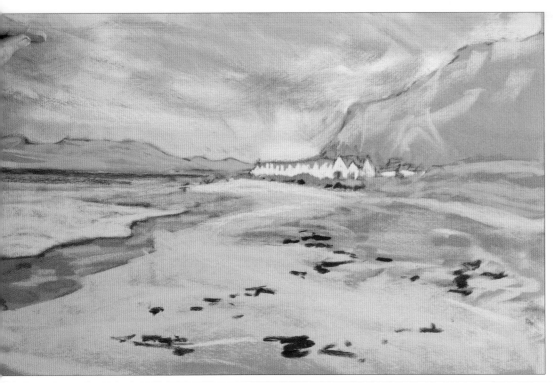

13 It is best to apply lots of pastel on this cork surface, as the pastel becomes more mobile as the tooth of the surface fills up. Go over the sky with grey to create the look of threatening cloud. Use this to dull down some of the colour in the rest of the painting.

14 Go over the sky with pale blue, using directional strokes to create the impression of a strong wind in the clouds. Lighten parts of the hills with the same colour.

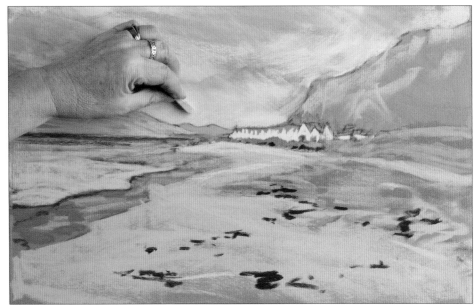

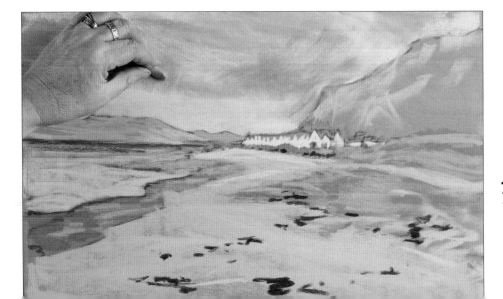

15 Apply more ultramarine to add depth to the sky.

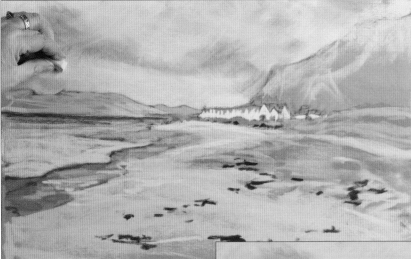

16 Lighten the sky again with more grey, and add touches to the beach as well.

17 Use purple-grey to paint the tops of the hills on the distant headland and the roofs of the cottages. Add touches in the greenery and on the beach, and directional tide lines to lead the eye to the cottages.

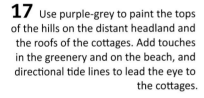

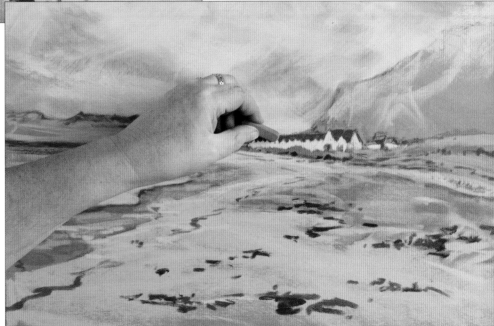

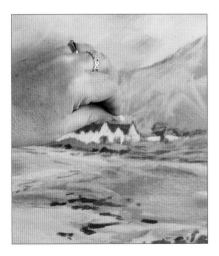

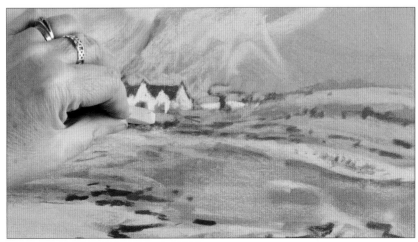

18 Use the pink of the hill to paint negatively round the cottage roofs to refine the shapes.

19 Use lilac to suggest small buildings behind the cottages.

20 Paint texture on the right-hand hill with a golden-brown pastel.

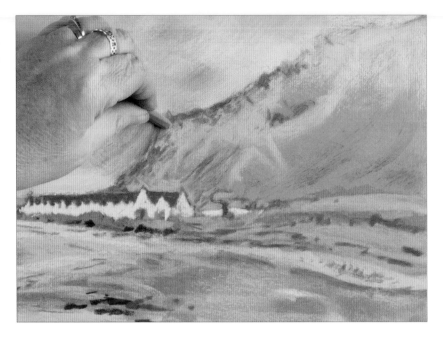

21 Add touches of warm green to the greenery.

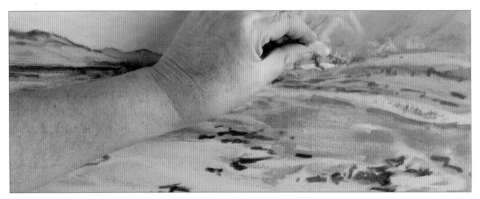

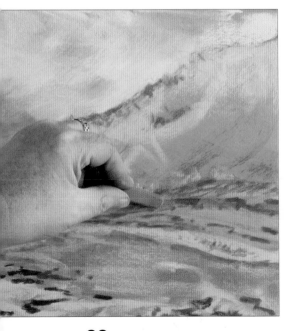

22 Darken the area to the right of the cottages with purple-grey.

23 Use a forest green hard pastel to paint greenery at the base of the right-hand hill and on the beach. Sweep the colour over the right-hand side of the beach.

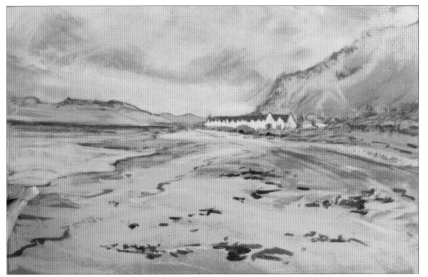

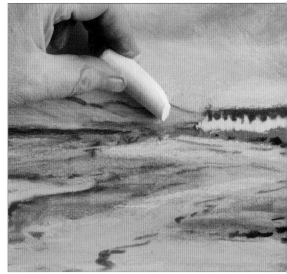

24 Paint cream soft pastel by the sea on the left and sweep and dot it over the foreground and the sea.

25 Paint the distant hills to the left of the cottages with ultramarine, then pale blue.

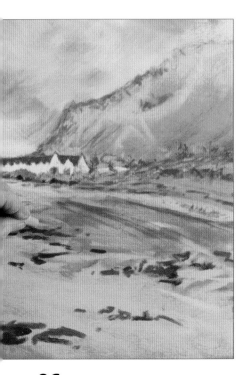

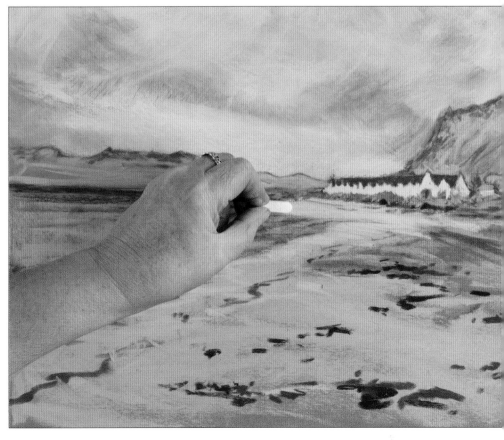

26 Use bright yellow pastel to dot gorse in front of the cottages, and add dots and dashes in the greenery on the beach.

27 Paint pale blue and cream pastel to lighten the beach in front of the cottages, and coming forwards from there.

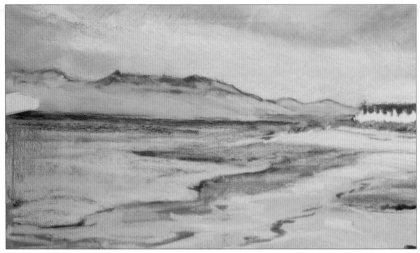

28 Bring the right-hand hill forwards by strengthening the colour with golden brown, then add pink on top.

29 Knock back the left-hand headland to make it look more distant, using very pale peach.

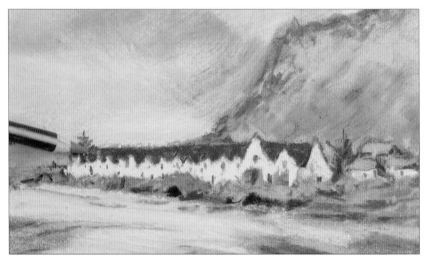

30 Paint specks of very pale blue in the water below the headland to add movement to the sea. Lighten the foreground sea and soften the edges with the same colour.

31 Use French grey pastel pencil to suggest the details of the cottages, adding windows and doors. Keep the marks irregular and loose. Add a tree behind the cottages.

32 Work on the sky, making directional marks with the ultramarine pastel.

33 Sweep pale blue over the top of the ultramarine and soften the colours in with your finger.

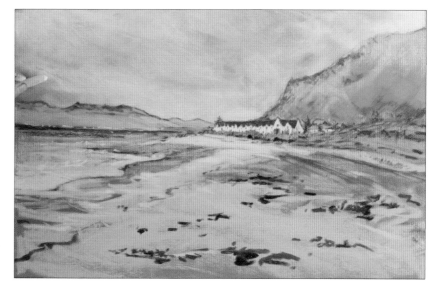

34 Use a pale blue hard pastel to go over the sky. The hard pastel glides over the top without despositing much colour, but has the effect of blending the colours beneath it.

35 Use the French grey pastel pencil to add another tree behind the cottages.

36 Paint a trail of rock in purple-grey soft pastel on the right of the beach, leading the eye to the cottages, and soften the colour in with cream soft pastel.

Overleaf
The finished painting.

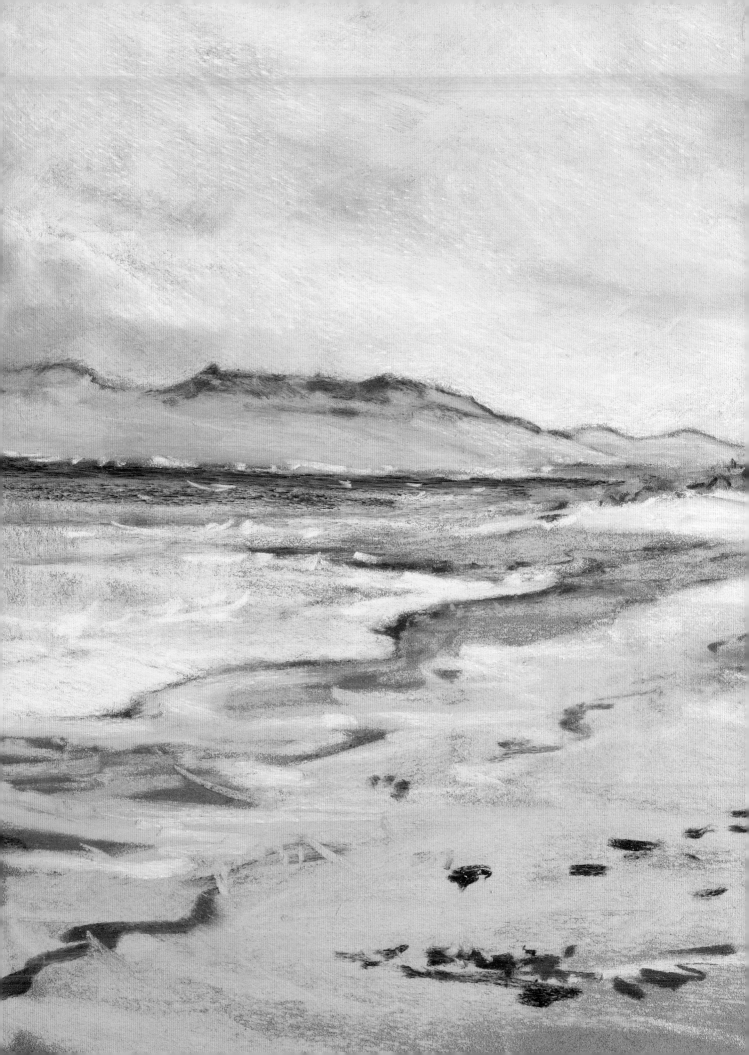

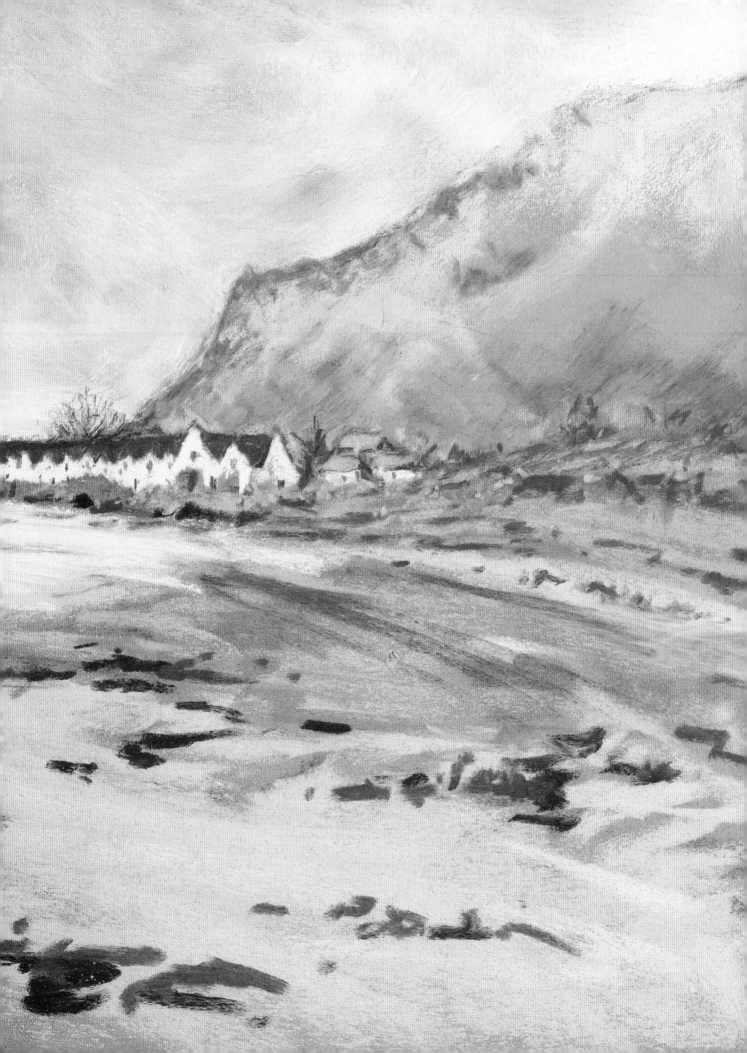

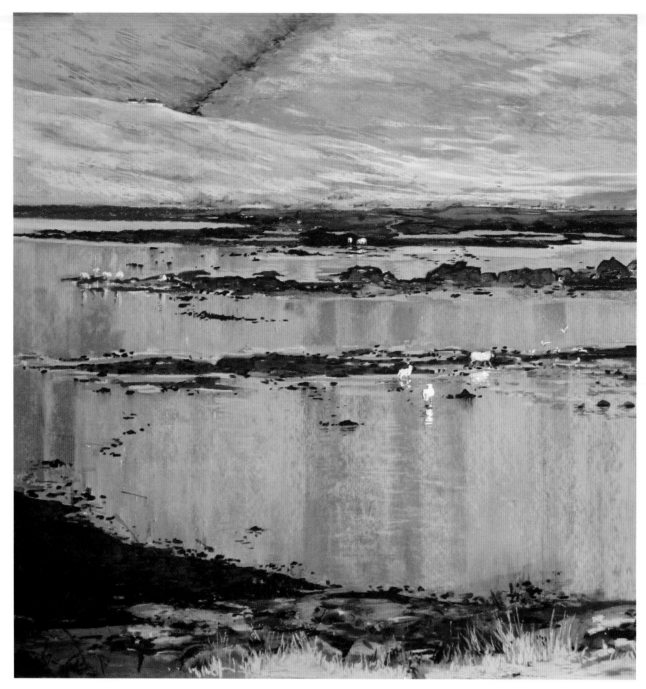

Low Tide Grazing

Sometimes cutting out the sky in a composition helps make the
earth colours more vibrant, and I am often attracted to tidal
subjects, where patterns are naturally formed by receding water,
so this scene really caught my eye as a strong painting subject.
I particularly loved the way the sheep were totally unfazed by
the tide and stood their ground!

Rocks at Armadale

The view from Skye across to the mainland offers an ever-changing array of moods and colours, and from the ferry pier, the grey slate tones of the shore seemed to echo the distant mountains and drifting clouds. A subject like this could be painted numerous times in different colour arrangements, and give endless versions to this stunning view, and Scotland is full of them!

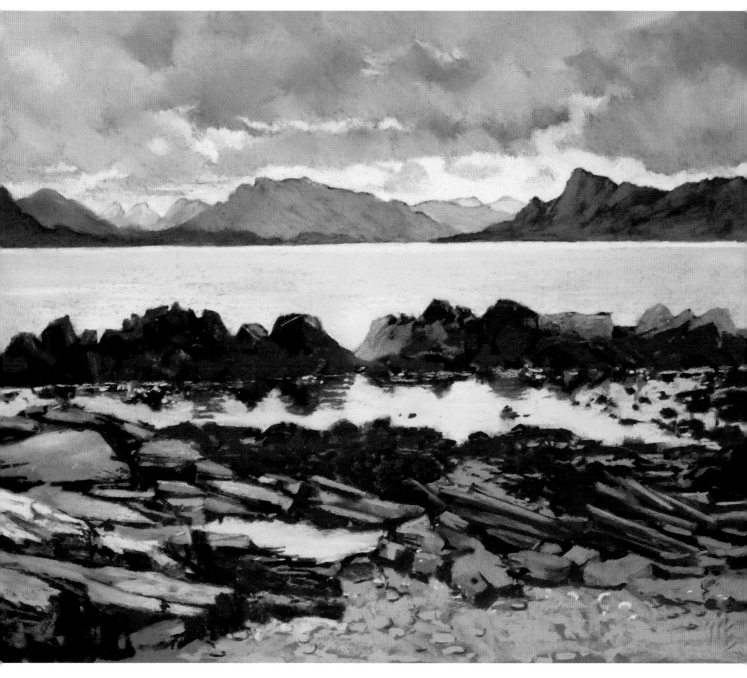

Garden Poppies

I wait impatiently every year for the glorious Oriental Poppies to flower in my garden, and every year I have to rediscover my strongest orange and red pastels. Nothing ever seems to match the intensity of nature at its best, but with the help of a dark paper, my stunning rose and poppy collections come to life and keep me busy all summer long! The contrasts of flowers against our lovely purplish Scottish stone makes a wonderful backdrop and inspires plenty of textural strokes with pastels. Painting from life is the best way to appreciate these textures and colour intensities and it helps to view the flowers in their natural habitat, rather than in a vase indoors.

The scene in my garden.

My outdoor set-up for painting this garden scene.

You will need

A dark-toned blue sanded pastel board

Light green hard pastel

Soft pastels: several strong oranges; light, medium and dark-toned greens; dark cool blue-green; light, medium and dark-toned purple-greys; pale and mid-toned pink; stone colour such as beige-grey and/or yellow ochre

2.5cm (1in) flat brush

The palette of pastels used in this project.

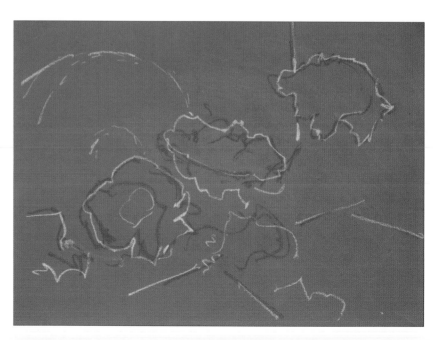

1 Sketch in the outline of the poppy group with a light green hard pastel to plan the main divisions of the composition. If you are not totally happy with this plan, choose an alternative colour to correct it, rather than erasing. Eventually the drawing will be covered with pastel anyway.

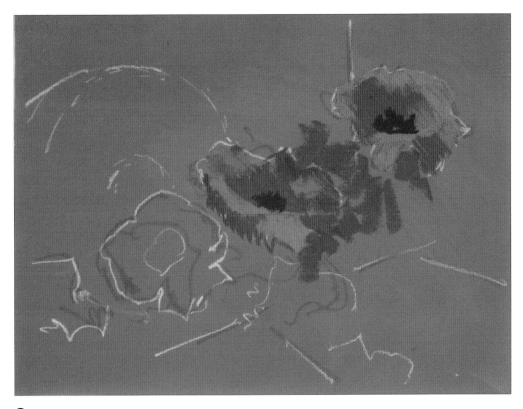

2 Using the deepest orange, block in two of the poppies, followed by a slightly lighter shade to create two tones. Block in the centres with the darkest purple-grey. Use mid-green to surround the flowers.

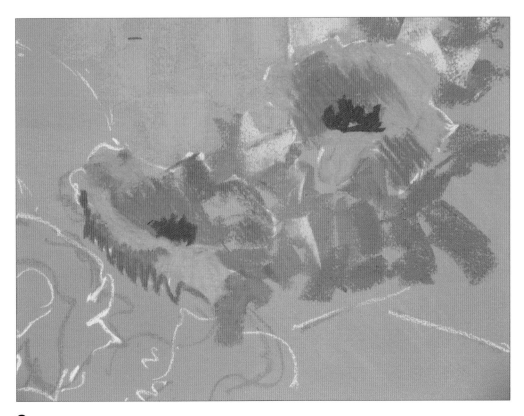

3 Add some purple-grey to indicate the wall. This is to show the approximate colour and tone relationships between surrounding areas. Add some lighter, cooler greens and a bluer dark green to give tonal variation.

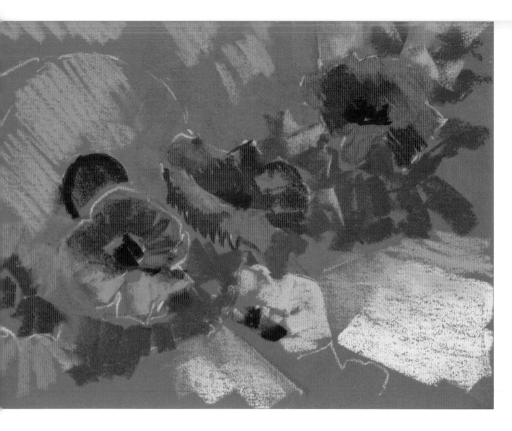

4 Block in the remainder of the surrounding area to indicate the main colour and tone relationships, with a lighter purple-grey for the wall, and two tones of yellow ochre or stone colour for the path. Block in the basic shapes of the third and fourth orange poppies, and one of the pink ones with a mid-toned pink. Indicate the centre of the millstone with the same dark purple-grey as the poppy centres.

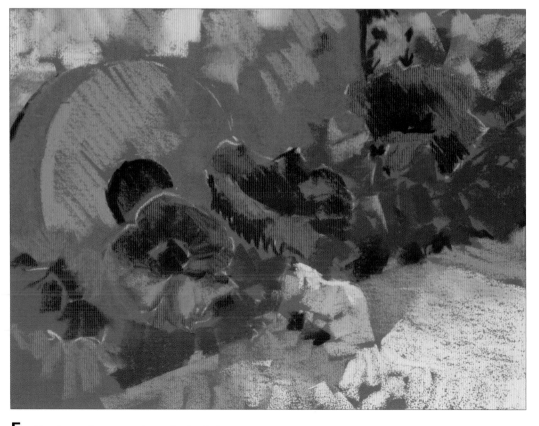

5 Add pale purple-grey on the wall. The darkest tones need strengthening now to create the impact of the shadows, both in the background and in the foliage. The dark purple-grey is used for the darkest touches. An overall impression of dark and light contrasts should now become apparent. Block in the second pink poppy.

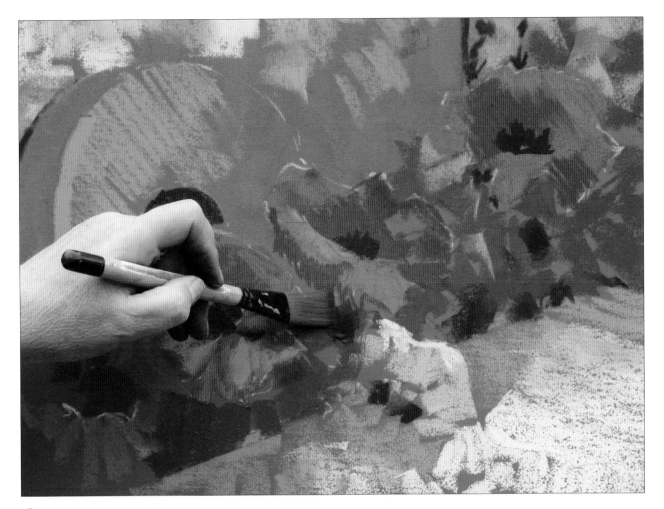

6 Using a damp 2.5cm (1in) flat brush, solidify the colour of the darkest corners of shadow, to intensify it. Note that if the brush is too wet, you will dilute the colour instead. This also makes the orange poppies stand out more in contrast.

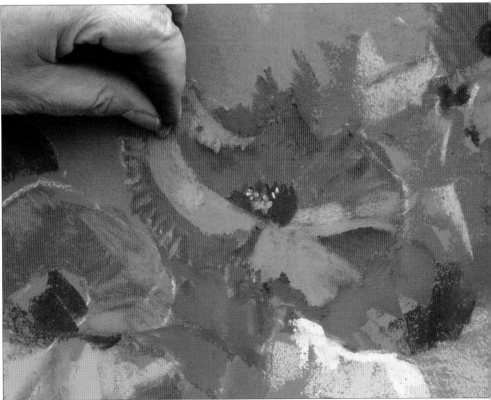

7 Add a few highlights to the main flower to bring it out and give it some texture. Use dashes of very light yellow-green and some blue-green in the centre, and oranges on the petals.

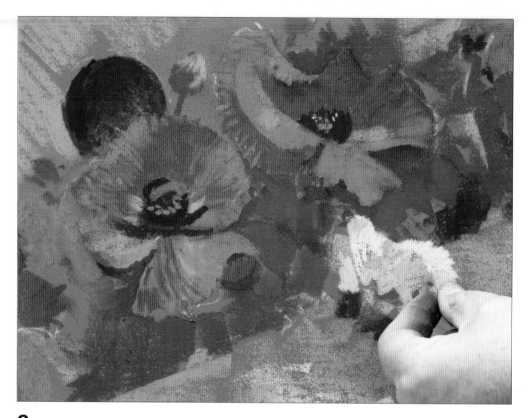

8 Continue highlighting the orange poppies. Add further highlights to the pale pink poppies to create a little more depth to the flower shape. Add seed heads in varying greens.

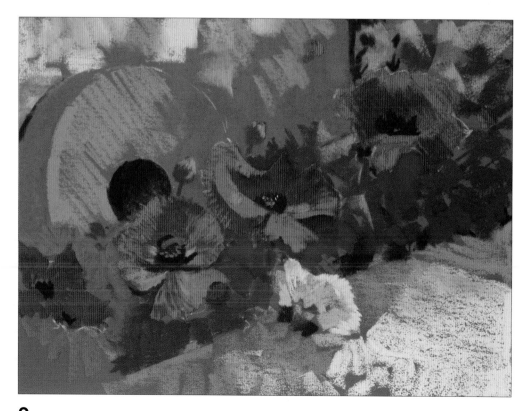

9 Block in the lowest flower in pink. This and the outer shapes of foliage are left without detail to create more intensity towards the centre, which is the focal point.

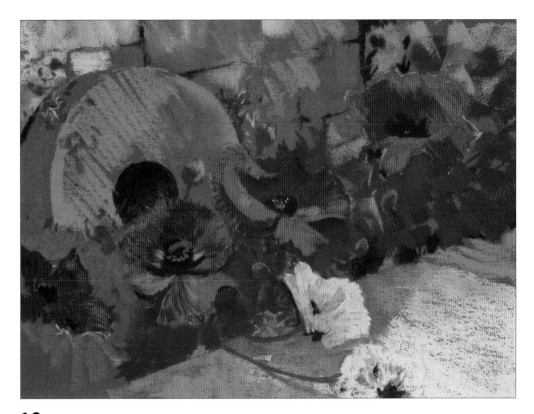

10 Working into the flowers, add varying tones to some of the petals to create more form, but do not add detail everywhere – leave some to the imagination and don't get too botanical! Add foliage to the background and suggest the stonework of the wall with the darkest purple-grey.

The two central flowers get the most shaping, but close up, you can see that the style is still loose and suggestive, rather than exact.

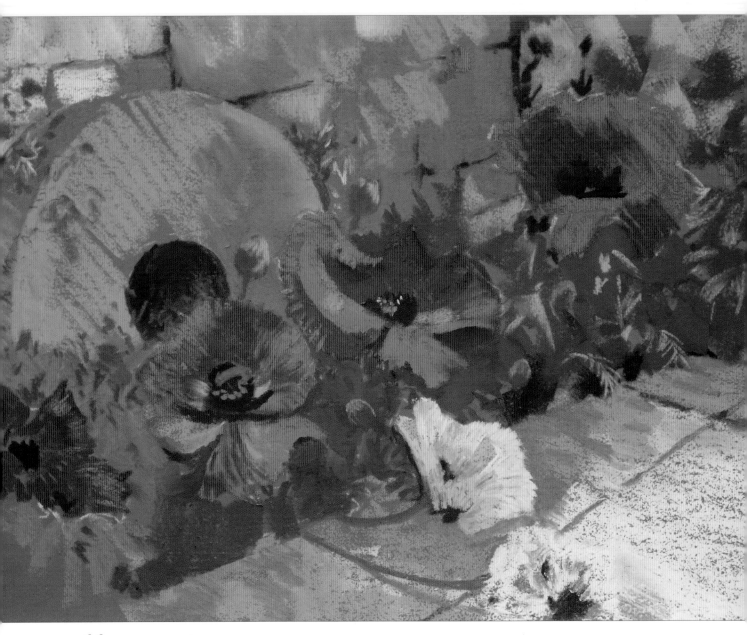

11 The overall composition is pulling together quite well now. Add further foliage shapes and more seed heads, as well as some pinks in the background foliage. Paint some more shadow on the path with purple-greys.

12 Add highlights to the centre of the right-hand poppy. Tidy up the edges of the main flowers and freshen the colours.

13 At the final stage, make adjustments around the entire composition with this limited palette to unify the picture. Use very light glazes of flower colours in the wall and pathway to link with the flowers.

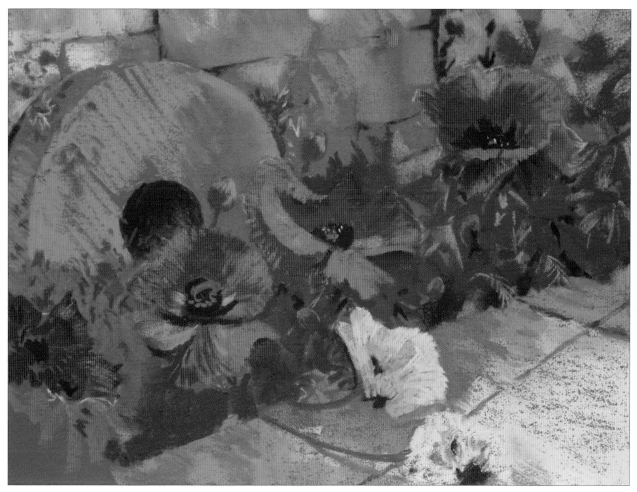

139

The finished painting

Overleaf, page 142
Giverny Iris

I was struck by the random planting at Giverny, which offered a complete contrast to the neat rows of pathways elsewhere. I couldn't paint on site, so I took lots of photographs and created this scene from one, plucking flower heads from various other photographs to build up my own composition. This added to the random quality of the design, creating a wild garden rather like my own!

Page 143
Giverny Poppies

Bringing a little more structure into this composition, I hinted at the formality of the pathways and planted rows, but used several other poppy heads as points of interest, reaching up from the base of the picture and stretching for the sky. More flowers are just suggested in a loose style, leaving the viewer to imagine what else is planted.

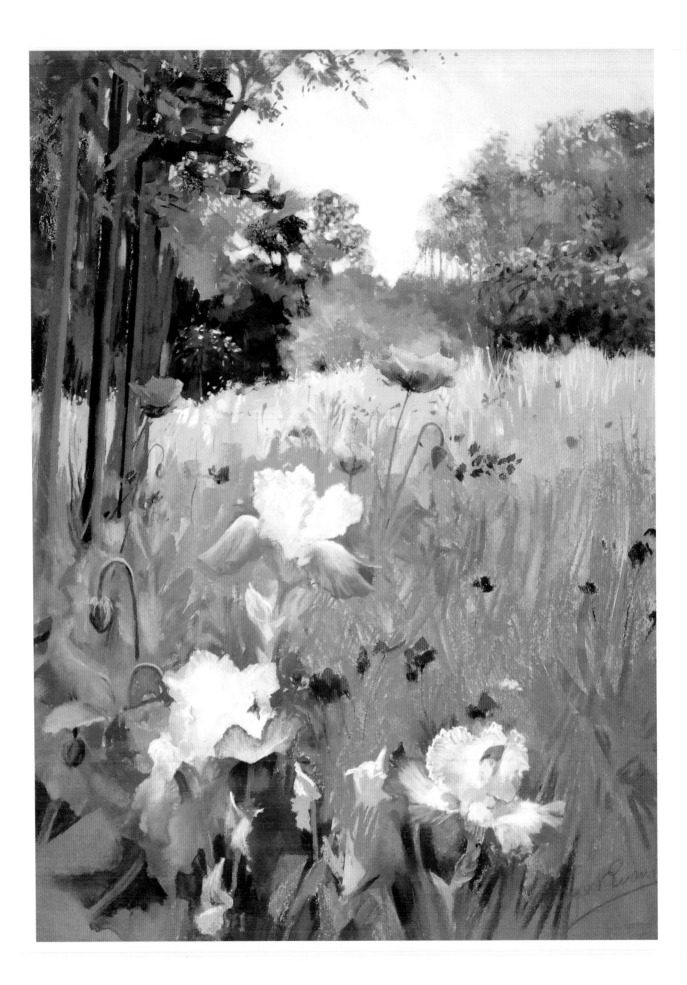

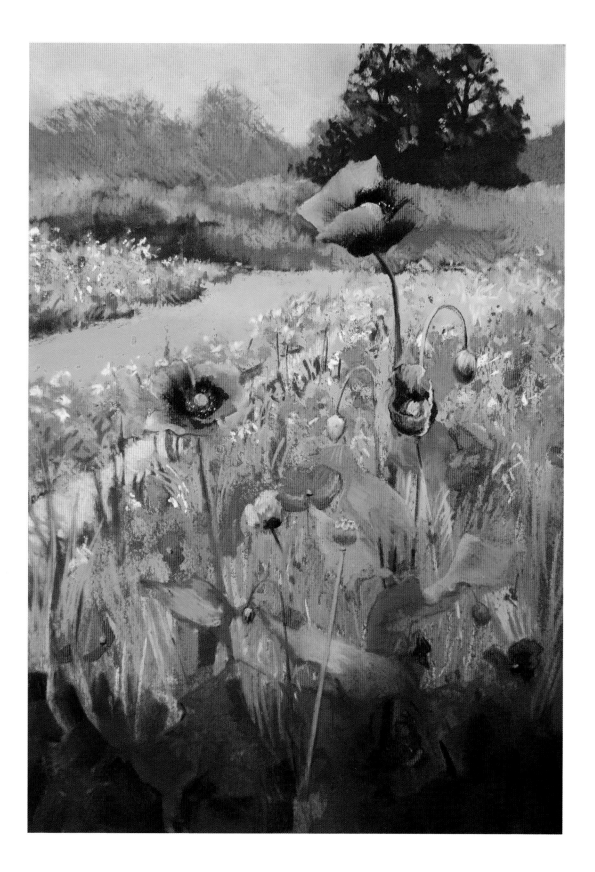

Index